IMAGES
of America

BLOOMFIELD

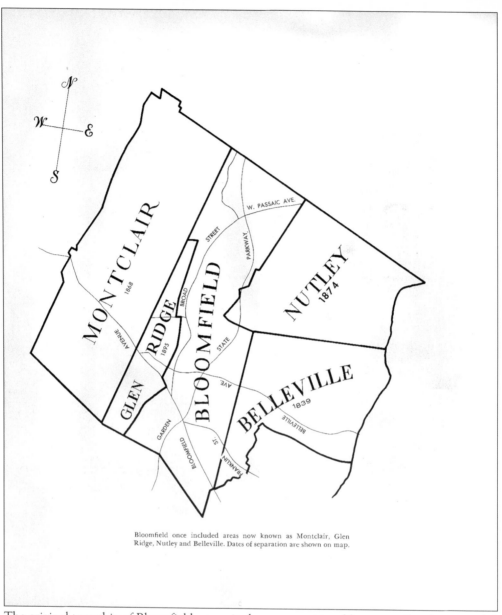

Bloomfield once included areas now known as Montclair, Glen Ridge, Nutley and Belleville. Dates of separation are shown on map.

The original township of Bloomfield was quite large, comprising 20 square miles that extended from the Passaic River on the east to the top of what the first settlers of Newark called First Mountain. This map, which was drawn in 1962 by Rachel Diamond for her sesquicentennial *History of Bloomfield: 100 Years Around the Green*, shows the township in 1812. It also shows the various towns that have since become independent: Belleville-Nutley in 1839, Montclair in 1868, and Glen Ridge in 1895. Montclair was originally called Cranetown and later West Bloomfield. Speertown became Upper Montclair, the portion of Montclair that lies north of Watchung Avenue.

IMAGES
of America

BLOOMFIELD

Frederick Branch, Jean Kuras, and Mark Sceurman

ARCADIA

Copyright © 2001 by Frederick Branch, Jean Kuras, and Mark Sceurman.
ISBN 0-7385-0504-8

First printed in 2001.

Published by Arcadia Publishing,
an imprint of Tempus Publishing, Inc.
2A Cumberland Street
Charleston, SC 29401

Printed in Great Britain.

Library of Congress Catalog Card Number: 2001086549

For all general information contact Arcadia Publishing at:
Telephone 843-853-2070
Fax 843-853-0044
E-Mail sales@arcadiapublishing.com

For customer service and orders:
Toll-Free 1-888-313-2665

Visit us on the internet at http://www.arcadiapublishing.com

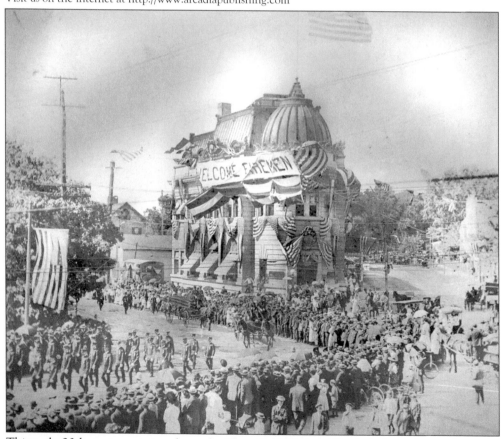

This early-20th-century picture shows the Bloomfield National Bank during a firemen's parade.

CONTENTS

Acknowledgments 6

Introduction 7

1. As It Was

2. Merchants, Mills, and the Morris Canal 33

3. Civic Pride 63

4. Townscape 111

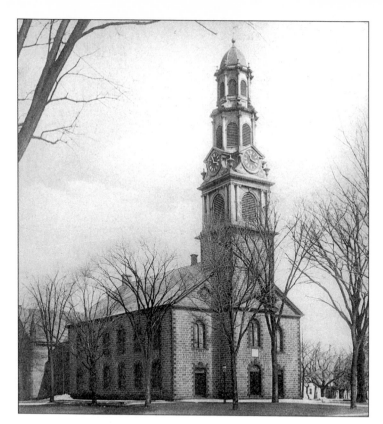

This postcard shows the Bloomfield Presbyterian Church on the Green. It was the old First Presbyterian Church.

Acknowledgments

We would like to express our thanks to those who have contributed in different ways to this book: Joan Gorman, Joan Swerdlow Millman, Dorothy Johnson, the estate of the late Aldo Tron, Bloomfield College, Ellen Bellinsky, photographers Edward Kamper and Henry Vollmer, the Bloomfield Fire Department, Isabelle Redfearne, Sallie Meyer, and the Glen Ridge Historical Society. For their excellent source materials, we are grateful to the Historical Society of Bloomfield and the outstanding, courteous, professional staff of the Bloomfield Public Library.

For help locating photographs, we are in the debt of the Historical Society of Bloomfield, which—under the leadership of curator Lucy Sant Ambrogio and the trustees—has carefully and thoughtfully preserved the collection in the society's museum.

We wish to express our sincere thanks to Sallie Black for her research of Bloomfield newspapers from the 1880s and 1890s, for working them into readable form, and for her infinite patience in providing detailed indices to this wealth of historical material on which we depended in researching material for this book.

Mark and I are especially indebted to our friend, Frederick Branch, who generously provided the dining room table, brewed the coffee, and shared with us his knowledge, respect, and affection for our town, Bloomfield.

—Jean Kuras

INTRODUCTION

The founding of Bloomfield proceeds from the founding of Newark. In May 1666, a group of seagoing vessels carrying about 30 Puritan families from the colony of Connecticut made their way up the clear waters of the "Pesayak River" seeking a new home where they could freely practice their religion. The righteous Puritans were nearing the end of a pilgrimage to a promised land in the vast wilderness. Knowledge of the landscape was vague. Little was known about it except that it was, by glowing report of Capt. Robert Treat, a land of rich fields and woodlands with plentiful streams.

In 1679, just 13 years later, English landowners cleared the land to the north. They began settling in the region along the Second and Third Rivers and the Native American trails that ran from the Passaic River to the top of Orange Mountain. The Crane, Baldwin, Davis, Dodd, Morris, and Ward families were among these first settlers.

At first, probably because of the threat of Native American attack, these people did not build houses on their land but preferred to live in the safety of the village of Newark. While we do not know if there was a house built before 1695, landlords did make use of woodlands and grazing lands, driving their cattle along routes that are still marked by modern roads to their plantations in the northwest.

At about the same time, Dutch settlers purchased a large tract of land adjoining the Newark settlement on the north from the Leni Lenape Indians. Originally called Acquackanonck, it was called Stone House Plains as early as 1696 and was named Brookdale in 1873.

In 1702, a sawmill was established on the Morris Plantation at Bay Avenue and Morris Place. Samuel Ward's wool mill began operation in 1725 and George Harris's mill shortly thereafter. Copper was mined in Watsesson and Chestnut Hill (now Glen Ridge) by 1735. With a mill to saw wood, a mill to card and weave wool, and an abundance of fieldstone to be quarried, the construction of houses began. Anthony Olive built a house in 1712; David Dodd's appeared in 1719; and Abraham Van Giesen's was built the same year on the Third River. Jasper Crane farmed at the headwaters of the Second River, and others followed him onto Watsesson Plain. About a dozen more houses, which have since been destroyed, were built before the American Revolution.

In the autumn of 1796, the community made preparations for the groundbreaking for a new house of worship on land donated by the Davis family. The congregation of the Presbyterian Society chose Bloomfield as the parish name and carved "Bloomfield, 1796" into the white marble tablet, which remains in place over the church's main door.

The area northwest of Newark remained attached to the expanding town but, by 1812, the

new township felt strong enough to assert its independence. The New Jersey legislature passed an act separating the township of Bloomfield from Newark. It was incorporated under the name "Inhabitants of the Township of Bloomfield in the County of Essex." The town embraced the area from the Passaic River to the Watchung Mountains and from Passaic County to Newark, a total of 20.5 square miles. Today it has an area of 5.4 square miles due to the creation of several new communities.

In 1839, Belleville was set off, taking 2,466 of the population, and leaving Bloomfield 2,523 people, according to the 1840 census. West Bloomfield, or Cranetown, separated and (with 3,000 of the population) formed Montclair in order to float bonds to finance the extension of the railroad to which the rest of Bloomfield was opposed. In 1871, Woodside, now North Newark and the Forest Hill section of Newark, also separated. In 1874, Franklin, now Nutley, became independent. A squabble over paved roads was the official reason for losing Glen Ridge in 1895, but relations had been strained for some time and the division was inevitable.

The industrial growth of Bloomfield was given a huge boost with the opening of the Morris Canal in 1824. Until then, the transportation of raw materials and finished goods from the early mills struggled over muddy roads and was a serious problem. The canal, however, provided a faster and easier way to bring coal from Pennsylvania and iron ore from northern New Jersey. New factories sprang up along its route, which ran from the Clifton border, through the Brookdale section, and then south to an aqueduct near Newark Avenue. There the canal turned east on its way to the Passaic River and eventually to Jersey City.

From the Civil War on, growth and changes in Bloomfield correlated with those throughout the nation. Large numbers of immigrants settled in the town. The community became more diverse as new houses of worship were formed and additional social and cultural organizations developed. New lines of business, commerce, and industry engaged citizens in the changing conditions and a challenging future.

In 1912, when the town celebrated its centennial, Bloomfield's 45 industries showed their products in an industrial exhibit at Berkeley school. More than 1,000 of the town's sons and daughters served in World War I. In 1920, the town's population reached 22,019. Ten years later, the town could boast of 85 plants with products ranging from organs and light bulbs to safety pins and silk stockings.

In 1962, when Bloomfield held its sesquicentennial celebration, it had grown to over 50,000 residents. Its growth was due in part to residential development, such as replacing farms in the north, converting one-family houses in the older section, and constructing new apartment complexes. Growth was further stimulated by the construction of highways and access to convenient transportation. The town benefited from the enterprising efforts of heavy industry, light industry, retail establishments, and professional and commercial services.

Today, institutions of government and education and a network of social, fraternal, and cultural organizations support dynamic changes. The wheel of time has carried the town forward to become a vital suburban community.

This book brings together a compilation of photographs that display the old town with respect, dignity, and sentiment. These are the images of people and the places they lived, labored, and led their lives eagerly to fulfill the promise of opportunity that America offered.

One

AS IT WAS

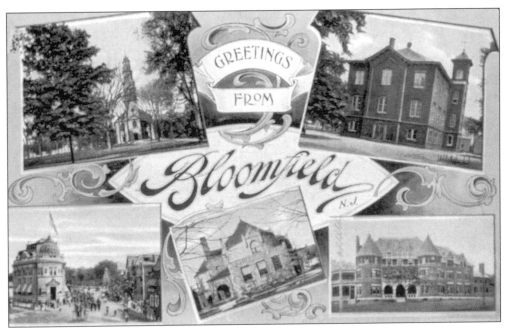

This early-20th-century postcard depicts some views around town.

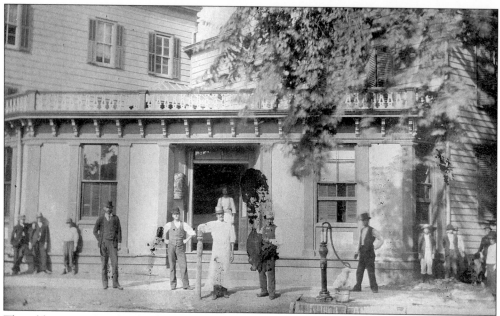

The oldest views in this book are these pre-1880s tintypes, which are believed to show the legendary Archdeacon Hotel at the corner of Bloomfield Avenue and Washington Street. Photographs of this structure are rare because it went up in smoke in 1883. By the time fire engines arrived from Newark, almost all of the business district was in ruins. This calamity led to the organization of a volunteer fire department. The engine house was located on Glenwood Avenue, just east of the crossing of the Newark and Bloomfield Railroad, later the Delaware, Lackawanna, and Western Railroad.

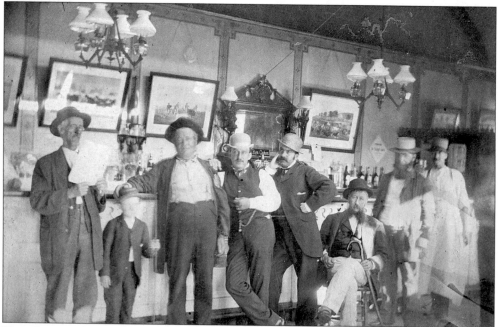

This photograph shows the interior of the Archdeacon Hotel. These people appear to be local citizens bellying up to the bar.

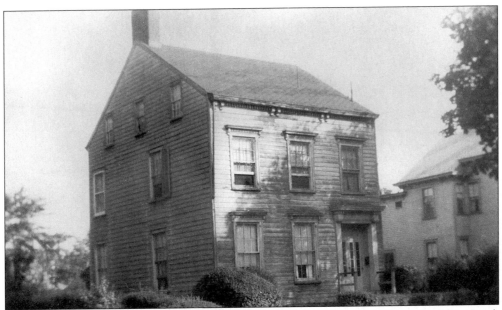

While he served as overseer of the poor, Judge Eliphalet Hall occupied this 1830s Greek Revival half-house at 27 Oakland Avenue. Town meetings are believed to have been held in its double parlor before Bloomfield established a permanent town hall in 1927. As early as 1818, Hall had been a partner with Jacob Kline Mead in a paper-making enterprise in Kinsey's old mill on Franklin Street. This 1947 photograph shows the house in derelict condition. It has since been restored by the current owners, Alan and Michelle Slaughter.

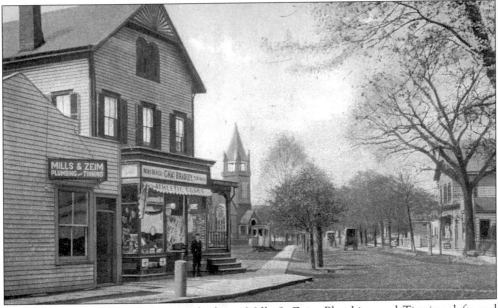

This early-1920s postcard photograph shows Mills & Zeim Plumbing and Tinning, left, and Charles Bradley Athletic Goods in Watsessing Center. Watsessing Methodist Church is in the distance. We imagine that shoppers tied up their horses to a boiler that was sunk into the ground in front of the Mills & Zeim establishment. The street, which today slopes upward to cross the railroad, was at ground level at the time of the photograph.

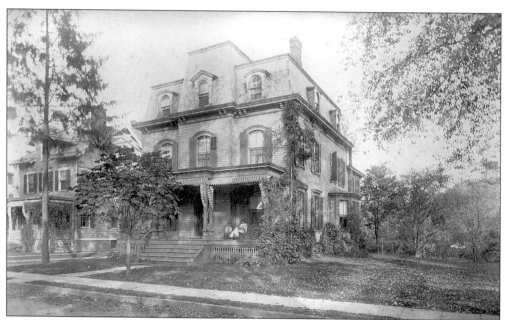

A handsome French Second Empire mansard-roofed house containing 15 rooms and one bathroom stood on the corner of Park Place and Liberty Street. It was replaced by the present four-story brick apartment house in the 1920s. The house to the left, which some might remember as the residence and office of Dr. Fager, has been remodeled and joined to the house on the other side to become the Park Manor Nursing Home.

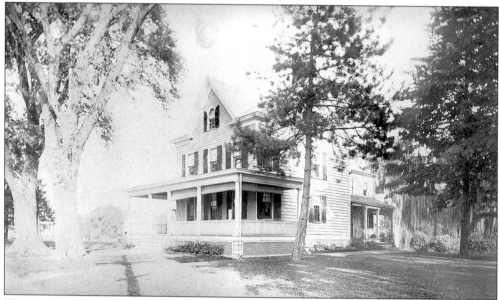

The Suydam house, located at 305 Broad Street, was on 3.61 acres that were landscaped with trees and shrubs. Its eastern boundary was the Morris Canal and beyond that the placid waters of Oakes Pond. The front section appears to date from c. 1870, but the rear wing may well be the original house shown on the map of 1856. Broad Street, after Franklin Street, is the oldest street in town. Anyone patronizing the funeral home or the car wash, which are now located on this site, would find it hard imagine that the property ever looked like this.

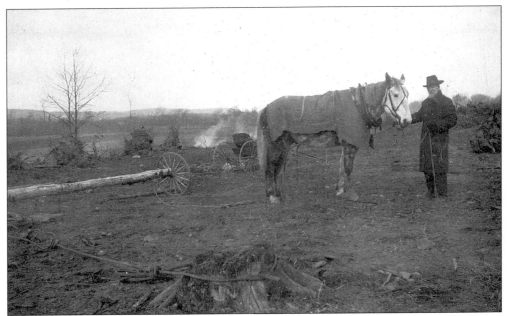

William Redfearn moved from Philadelphia in 1889 to work as a master weaver in the Oakes Woolen Mill. He came to this country from England right after the Civil War. His claim to fame was that he saw Abraham Lincoln in his casket. Redfearn lived on Pitt Street in back of Brookside School, then a one-room schoolhouse. When he retired, he bought a plot of land at Watchung and Broughton Avenues, where he and his wife built a house with the help of his horse, Dolly. Redfearn lived to be 92.

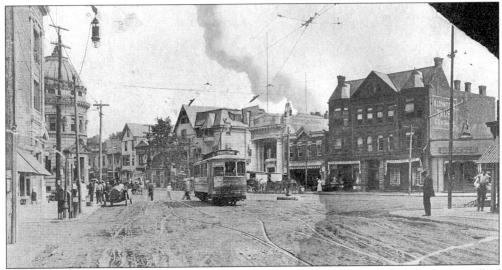

This postcard view was taken sometime between 1925 and 1930, the only period when all of the buildings shown existed. The electric trolley was on the crosstown line, which began at Eagle Rock Avenue and had its terminal at Bay Avenue. The old American House Hotel, at the center of the photograph, was demolished in 1929 and replaced by Abraham Lipton's first store. The Beaux Arts dome of the Bloomfield National Bank, to the left, disappeared in 1930 when that institution merged with the Bloomfield Trust Company.

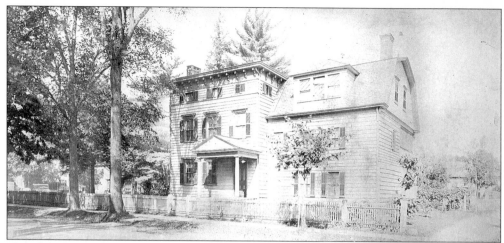

The original portion of this house was built by David Baldwin Jr. William Bradbury, composer of Sunday school hymns, lived here in the mid-19th century. Bradbury was active in the affairs of the First Presbyterian Church, just across Newtown Road (now Belleville Avenue). He was the grandson of John Bradbury and Mary Baldwin. This family connection may be how he came into possession of the house. The Baldwin house is shown on the Bloomfield map dated 1820, but the map could date from before 1796, as it does not include the Presbyterian church. The only original part of the Baldwin house that remains is the present wing to the right. The left-hand side was probably added in the 1850s, possibly by William Bradbury.

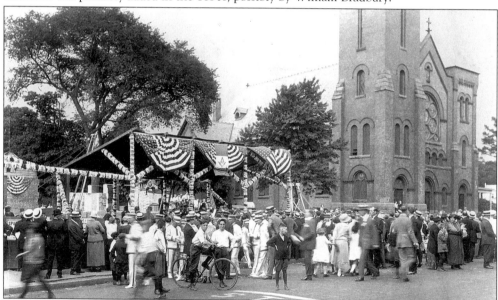

On July 24, 1824, members of various Masonic lodges met at the home of Joseph Munn to form a Masonic lodge in Bloomfield. As an incorporated municipality, the town was 12 years old when Bloomfield Lodge No. 48, Free and Accepted Masons, was instituted. It was the town's first fraternal organization. That lodge suspended operations in 1828, but was reorganized in 1850 under the title Bloomfield Lodge No. 40. On Saturday June 21, 1924, the cornerstone for the Masonic Temple, on the southwest corner of Broad and Liberty Streets, was laid. The ceremony was preceded by a parade of Bloomfield lodge members and guests. On the grand day, Andrew Foulkes was assisted by John Caulfield and Joseph O'Breiter.

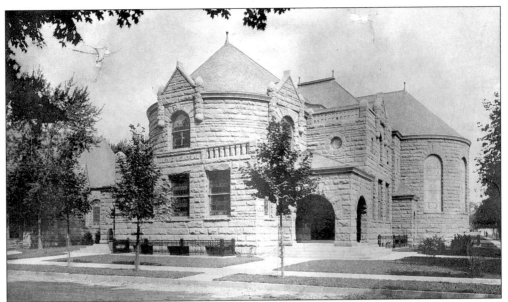

In 1902, James N. Jarvie, a prominent businessman, erected a parish house for the Westminster Presbyterian Church in memory of his parents. It is now Bloomfield College's Westminster Hall. The architect's plan included a library. An endowment of $5,000 funded the purchase of new books and periodicals. Use of the reading rooms was free, and for $1 any town resident could borrow books. By 1923, the Westminster Sunday School needed more space. Jarvie offered the town all of the library books and equipment along with $60,000 if a new library building were provided and the library supported by tax money. The voters approved his offer in a November election. While plans for the new library were laid, the Free Public Library, Jarvie Foundation was opened in Jarvie Memorial Hall in January 1924.

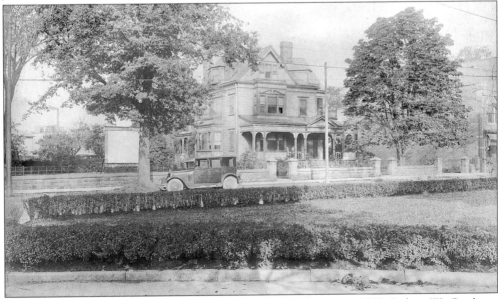

This house on Broad Street was built in 1851 by A.N. Baldwin. In 1883, Robert W. Gardener bought the property from Horace Pierson. Two years later, the Gardener family spent the summer in the Park House Hotel while the house was enlarged and improved.

The businesses shown in these four 1935 photographs were located on the west side of Broad Street, beginning with Lobbato Shoe Repair at No. 18. Next door was Ruvo's Confectionery and Sing Laundry. Peter Quinn, No. 24, handled two kinds of real estate—one of them in the cemetery. The well-remembered John Moran was at No. 28 (see p. 60). The Great Atlantic & Pacific Tea Company (A & P) was at No. 34, and next to that was the Essex County Building and Loan. At No. 40 was Heckel's Meat Market, an old Bloomfield firm. Then came Cranes

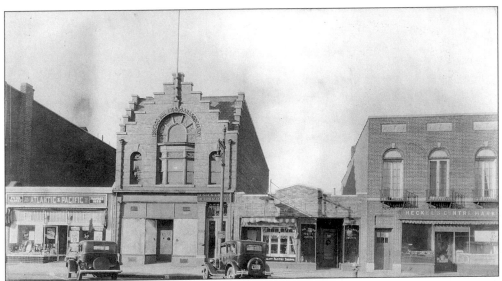

Corset Shop (a relic from the Victorian era), Moses and Gotleib (tailors), and then the grand, brand-new Park Building at No. 50 (the site of the old Gardner-Baldwin mansion). Roth and Schlenger, United Hardware, and other tenants filled the five stores in the new building. Next there was the Harper Method Beauty Shop at No. 58, and Hoffman's Confectionery on the corner in the Masonic Temple, No. 62.

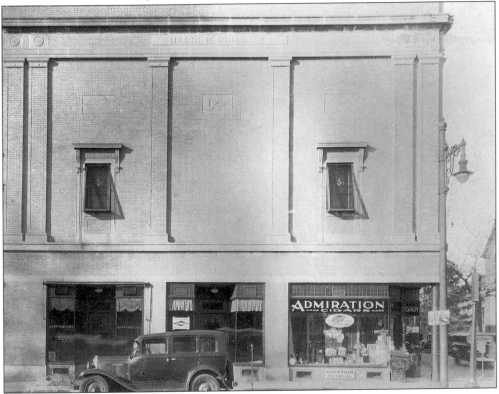

This is the Ephraim Morris house, at 81 Bay Avenue. The area around Bay Avenue was called the Morris neighborhood after the family who settled there in the early 1700s. It became a thriving industrial center because of waterpower provided by the Third River and, after 1831, the shipping facilities of the Morris Canal. Ephraim Morris served as general manager of the canal from 1832 until 1848. All 23 incline planes were from designs made by Morris and were built at his mill, located at Bay Avenue and Morris Place until it was torn down in the 1890s.

Charles Moreau Davis was the son of Caleb Davis and Hannah Dodd. The school that he founded was one of the first private schools to be built in town. The school for boys existed from 1851 to 1868 at the corner of Spruce and Liberty Streets. The c. 1850 building was used by Bloomfield College as a dormitory when this photograph was taken in 1947. It was demolished and replaced by the college's science building c. 1969. The heavy carved walnut front doors are now in the Historical Society of Bloomfield's museum.

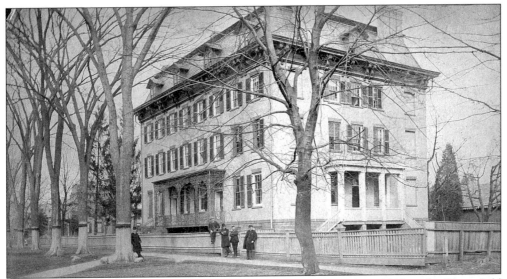

This photograph of Seibert Hall was taken on April 12, 1887. Built in 1810 as the Bloomfield Academy, the building was constructed with bricks made of clay that was taken from the northeast corner of Bloomfield Cemetery. The German Theological Seminary purchased the property in 1827 with the objective of educating young men for the ministry. The building is named for Dr. George C. Seibert, a member of the faculty for 30 years. Bloomfield College, now a four-year liberal arts college, was established in 1868 by the Presbytery of Newark as the German Theological School. Seibert Hall remains part of Bloomfield College today.

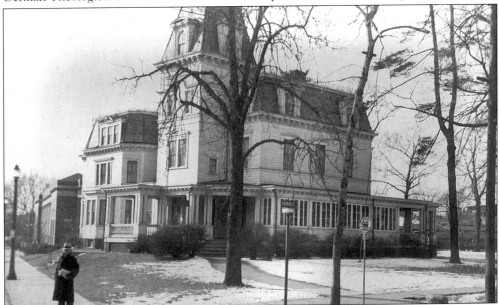

The Bloomfield Women's Club was organized on October 13, 1920. For some time prior to this, Mrs. Frederick G. Shaul had recognized the need for such an organization in town. Due to the work of Shaul, more than 20 women responded to the call and organized the club. The club's goals are to better government and education, to promote sociability, and to stimulate interest in art, music, literature, drama, homes, and gardens. The clubhouse, which had been the home of G. Lee Stout, stood opposite the town hall and was demolished in the early 1950s.

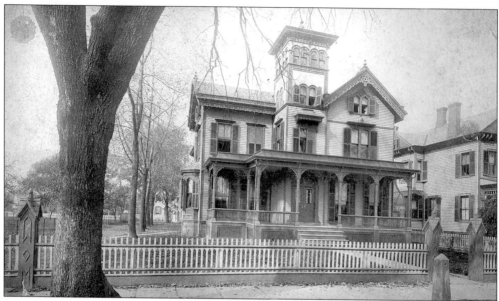

The house at 98 Broad Street is an imposing Italianate mansion, which faces the Green, next to the Children's Library. Drastic remodeling has since removed the tower and decorative details. The front porch has been enclosed, and a boxy wing has replaced the bay windows on the south. Little remains to suggest that this building is more than a century old.

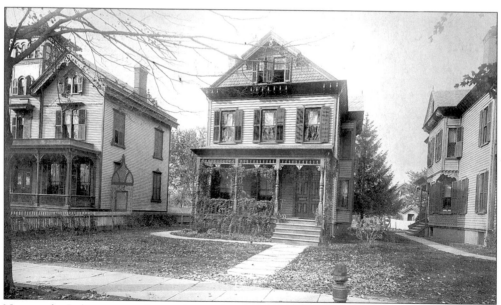

Next to the Italianate mansion to the north are two smaller houses, both extant today although considerably changed in appearance. Together, these four photographs show the west side of Broad Street, from the lawn of the Amzi Dodd house to the Methodist church on Park Street. All of these buildings still stand today.

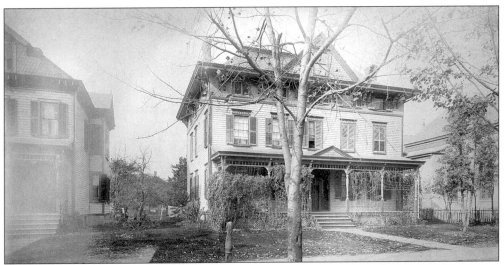

The house at 112 Broad Street is shown as it appeared in the early 19th century. Containing 15 rooms, it had previously served as the Bloomfield Female Seminary, a private school for young ladies presided over by Harriet B. Cooke. The mansard roof is a late-18th-century remodeling, possibly done at the same time as a similar change in Bloomfield College's Seibert Hall. The original Methodist church of 1880 stands at the right of the old seminary; it was replaced by the present church in 1928.

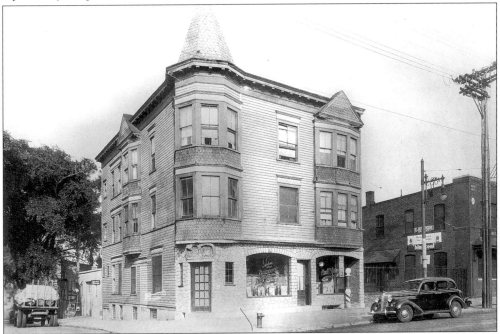

Dating from the 1890s, Brady's run-down hotel at the corner of Bloomfield Avenue and Conger Street might as well have a "Flop House" sign over the door. There was a tavern on the first floor, no doubt well patronized by hotel guests. Over the door to the tavern is a stucco relief that remained in place until the building was razed in the late 1960s. This photograph might have been taken on a Sunday morning since there is an unusual lack of activity on Bloomfield Avenue and the tavern is closed.

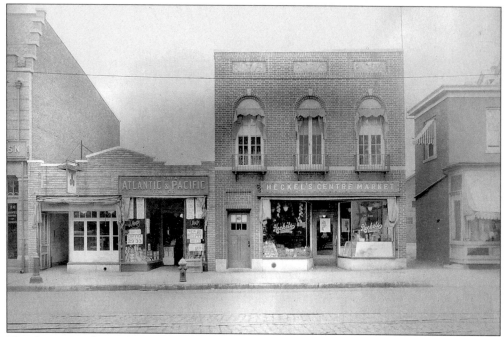

The Centre Market, a favorite with Bloomfield families, was opened in 1878. R.E. Heckel and his three sons ran the business, the stock of which included fresh, corned, and smoked meats; poultry and game; a large variety of fresh fruits and vegetables from their own farm; and fresh fish and oysters. "You will always get your money's worth" was Heckel's 1878 slogan.

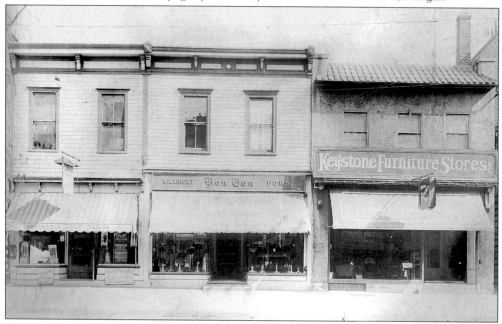

The Bon Ton Millinery shop was established in 1919 at 39 Broad Street by Mrs. M.L. Lichter. The oldest millinery shop in town, it prospered under her management. Mrs. Lichter, a lifelong resident of Bloomfield, was the daughter of William Loebel, who started a dry goods store on Glenwood Avenue in 1892.

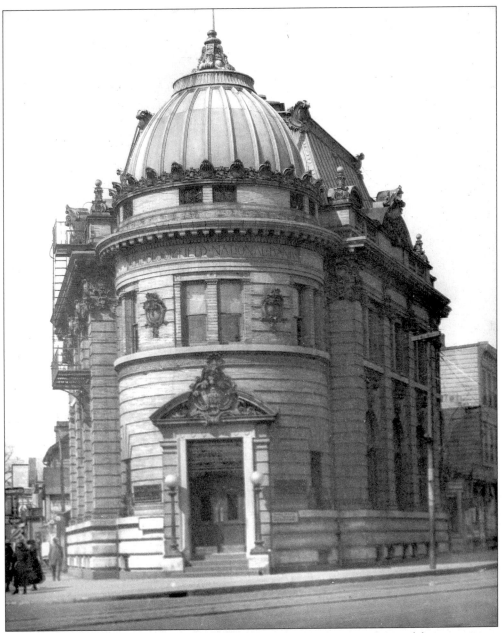

As late as 1902, this important corner in Bloomfield Center was occupied by a two-story structure that supplied hay and feed for horses. This changed as the five corners became more important commercially. The new Bloomfield National Bank resembles part of Charles Garnier's Paris Opera House, a style that was pretty impressive for a small New Jersey town. By 1929, the Bloomfield Trust Company and the bank merged to become the Bloomfield Bank and Trust Company, creating a need for a larger and more impressive modern landmark. After serving for a mere 27 years, the old bank was demolished.

This is a view of the entire Park Building, which was built on the site of the Gardener-Dodd house in 1925. Abraham Lipton relocated his store to the center section of the building, later expanding to occupy the entire first floor and basement. Even after retirement, Lipton stood at the door of his establishment to greet his longtime customers.

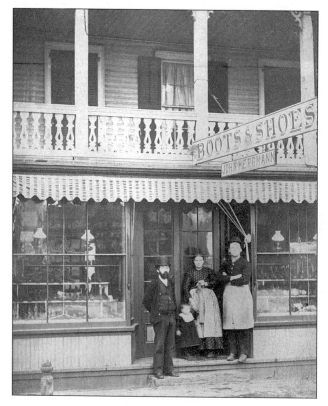

Bloomfield's first concentration of businesses and shops was on Glenwood Avenue even though it ran only as far as the railroad until the time of the Civil War. This 1887 photograph shows John Herrmann's shoe store, located at 308 Glenwood Avenue, about midway between the Center and Conger Street. Above the store was Unangst Hall, once a popular meeting place for lodges and social affairs.

In the 1870s, the editor of the *Bloomfield Citizen* would stroll around town on a warm spring day and call citizens' attention to changes and improvements on the landscape. On May 9, 1874, he described the west side of Washington Street: "On Washington Street we must name the fine residences of T.W. Langstroth, W.G. Raynor, Jas. A. Hedden and Wm. F. Lyon, all with ample grounds. Also the fine homes of P.J. Ward and Wm. Dodd, all with their own acres of surroundings." At that time, there were no buildings on the opposite side of the street. The property was owned by the widow of Judge Amzi Dodd. All of this changed by 1912, the date of this photograph of the former Unangst home, which at the time was occupied by the Elks and was decorated for Bloomfield's centennial celebration. In 1923, the Elks constructed a fine new building at the corner of Ward Street and Bloomfield Avenue.

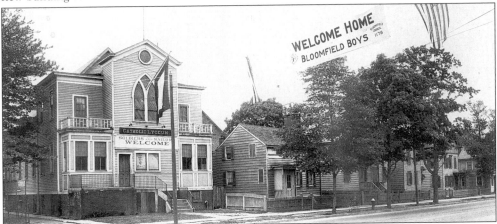

In 1887, Father Nardiello, the founder and first rector of Sacred Heart Church, purchased a lot on the south side of Bloomfield Avenue for $600. In that same year, a clubhouse was built to provide wholesome surroundings for the recreational and social activities of the parish's young men. It existed under a variety of names such as the Young Men's Literary Union, the Catholic Club, and the Lyceum. Father Nardiello was concerned that the 1887 clubhouse had become inadequate for Lyceum activities. When the new church on Broad Street was completed in 1892, the old church was given to the Lyceum to provide more space. The corner windows were replaced with bay windows and two balconies were built. The old church became the scene of indoor athletic events. In 1922, when the parish made plans for a new school on Bloomfield Avenue, the Lyceum was razed.

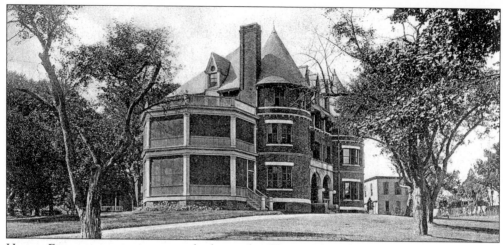

Horace Freeman was an insurance broker with offices in Newark. His Bloomfield residence, located at Bloomfield and Watsessing Avenues, became part of today's Job Haines Home. Freeman's house and four acres of property were purchased in 1898 for $10,000 by the trustees of the Job Haines Home for Aged People (on Shipman Street in Newark) when the need to expand asserted itself and the trustees made plans to move their home to Bloomfield. Their financial foundation was the result of gifts from Frank Haines. His generosity encouraged the trustees to name their facility in memory of Haines's father, Job Haines, a flour merchant, businessman, and elder of the Presbyterian church.

Ground was broken in 1902 for a new home, but the grand west wing was not built for another 28 years. The original cottage was torn down in 1967. Since 1993, the Job Haines Home has undergone a major expansion and remodeling.

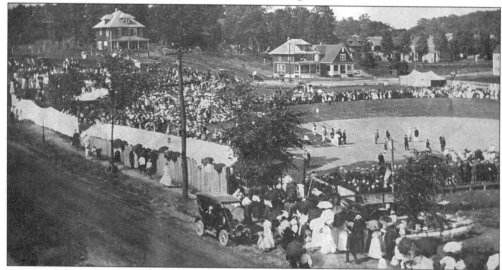

The Williamson Oval was the scene of many spirited baseball games in the early days of the last century. Located at the intersection of Liberty Street and Berkeley Avenue, the Oval was a natural amphitheater on grassy slopes. Townspeople amused themselves with Fourth of July celebrations as well as exciting games played by Bloomfield baseball teams and their rivals. At one time, the property was offered to the town as a playground, but the town fathers decided against it; real estate firms took over the tract and developed it with houses. This photograph shows the Williamson Oval on July 4, 1909.

In 1869, an association of citizens produced a legislative charter for the purpose of providing the town with a public library and hall. A lot was purchased at the corner of Broad and Liberty Streets and a three-story brick building was constructed in 1874 for a cost of about $25,000. It contained the necessary rooms for a library and a large hall fitted with a stage and a seating capacity of 1,000. About 500 volumes were collected for the library. On the ground floor were two stores. Through financial and other troubles, the association failed. The property was purchased by a few of the former stockholders. The building was advertised for sale in 1888.

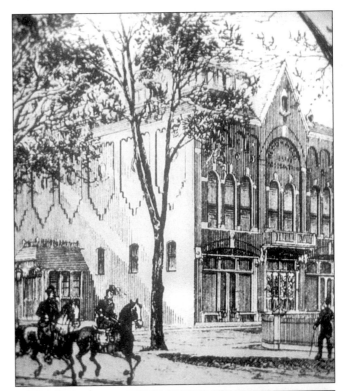

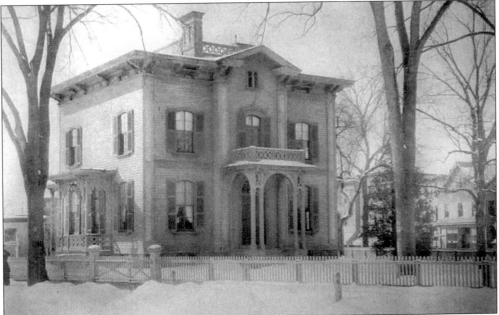

The old William K. Peters mansion at the junction of Broad and Franklin Streets was built around 1839. Peters was the town surveyor and a member of the Township Committee. The house contained 12 rooms and was in a prime location facing the Green. In 1933, Martin Realty Company bought the property. The house was demolished and replaced by the stores that stand there today.

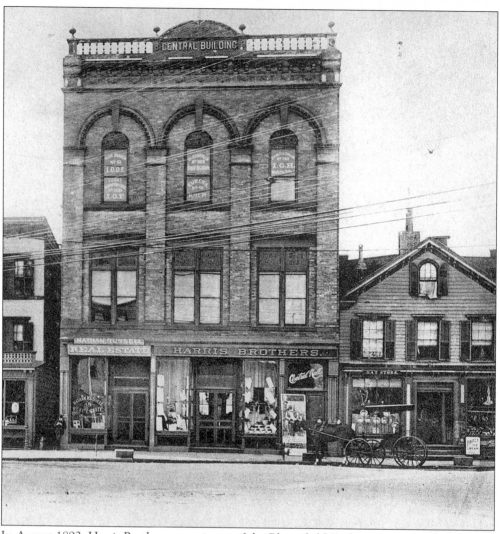

In August 1892, Harris Brothers, proprietors of the Bloomfield Beehive, announced plans for a new modern brick building to be built at the Center. It was expected to be "a three story structure, . . . dimensions 40 by 200 feet. The first floor divided into two stores, one of which will be occupied by Harris Brothers themselves. The second floor will be a public hall capable of comfortably seating 600 people, and, under pressure, 1,000 people will be able to get in."

This passage is an example of the disregard for public safety that resulted in many injuries or deaths in fires in public gatherings. Although considered fireproof in its day, the Harris building it was completely gutted by fire in the fall of 1978. The store to the left of Harris Brothers was rented by Nathan Russell Real Estate.

This is the way Watsessing Center appeared in 1905. After a heavy rain, it was a muddy intersection. Macadam was laid in 1912. The store to the left was the Watsessing Pharmacy. The building on the left was the Dorting's Bar and Hotel. The factory building in the far rear was the Empire Separator Company, a Swedish firm that sold cream separators to dairy farmers all over the country. The building on the right was McCarthy's Bar, which was demolished in 1912.

James C. Beach had a street named after him, which is not surprising considering he had purchased large plots of land in that location in 1851, 1854, and 1856. He intended to use the land to build a large house for his bride, Mary Butler, then a teacher in Madam Cooke's school on the Green. James Beach was very active in civic affairs and sang in the choir of Westminster Presbyterian Church, which he helped found. The Beach family moved out of the original house for a short time in 1882 while it was enlarged and redecorated. When the extensive renovations were complete, there were 16 rooms, two baths, a glass enclosed conservatory, and a tower with a mansard roof.

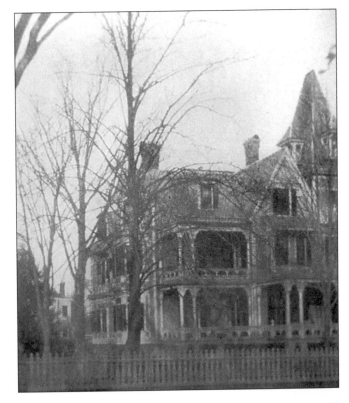

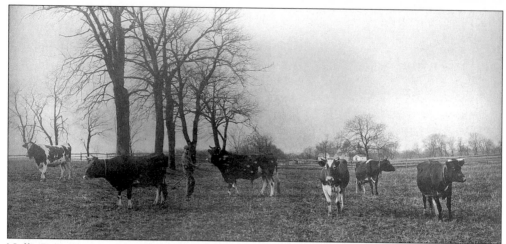

Noll's Dairy Farm occupied a large tract of land at the border of Bloomfield and East Orange on a road later named Arlington Avenue. The farm was divided by the construction of the Orange branch of the Newark and Bloomfield Railroad. The Noll residence and other buildings were on one side of the tracks while the pastures were on the other. Noll sold the vacant land *c.* 1900 to the Sprague Electric Company as a site for their new factory. The Noll family continued to live on their large homestead on the east side of the railroad until the 1920s, when the house was razed and replaced by a parking lot for the employees of Sprague's successor, General Electric.

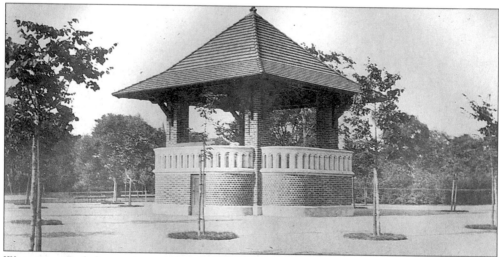

Watsessing Park began as a millpond formed by a dam built near what is now Bloomfield Avenue. The pond powered a mill to the east near the old road to Bloomfield, Franklin Street. During its more than 100 years of operation, the mill produced paper and related materials. When the enterprise was abandoned, the three-story mill buildings were left derelict until they finally burned to the ground. When the dam washed out, a wasteland of puddles and weeds lay within a few blocks of the business district. The owners of the pond had divided it up into building lots, but the surveyor they employed botched the job so badly that no one was sure where his piece of property began or ended. The problem was solved by a group of public-spirited citizens called the Town Improvement Association. They transformed the land into Watsessing Park. A new bandstand was erected and public concerts, school picnics, and Fourth of July fireworks were held there for many years. (Courtesy of Joan Gorman.)

Brookside Park underwent a $218,000 improvement project between 1994 and 1998. The park, with a river running through it, was beautified and re-created with new playground equipment, acorn-scroll gaslamp-style lights, tranquil walkways equipped with comfortable benches, and overlooks providing views of the snake-shaped river.

The old Dutch Reformed Church of Stone House Plains, later known as Brookdale Reform Church and now Brookdale Community Church, was the town's first Dutch church. It originated in 1795 in a Broad Street barn owned by Abraham Garrabrant. The congregation's first church was built in 1802; it was a frame building, partly made of stone with no steeple. In 1857, after a fire destroyed the church, it was rebuilt with stone from a quarry in Great Notch. On Good Friday in 1910, the second church was partially destroyed by fire. The four walls stood in good condition and the present church was built with the same walls and an additional brick section.

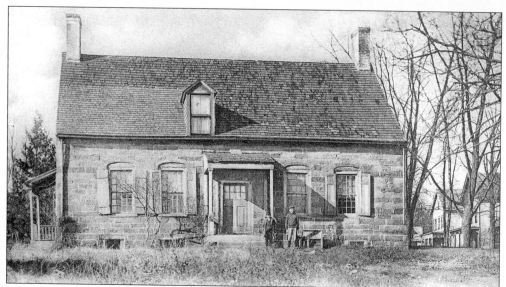

One of the most historic homesteads in town was the Thomas Cadmus house, located at 233 Ashland Avenue. The Cadmus family was one of the early settling families of Bloomfield. Thomas Cadmus was a farmer. Considered a mansion for its day, the house was built of stone and was one and a half stories high with a steep gable roof. Over the entrance was a stone carved with the family crest of a heart design between the letters T and C and the date 1763.

The New Jersey Militia and the Continental Army frequently passed through the area. Supposedly, Thomas Cadmus's son Hermanus Cadmus was about four years old when George Washington and his troops came by and stopped at the house. While dinner was being prepared, the general sat beneath the family's cherry tree, put the youngster on his knee, and entertained him with stories. Many believe the event occurred in 1776, when the American army was in retreat across New Jersey. Hermanus Cadmus lived to a ripe old age, dying in 1869. The Cadmus house remained in the family until it was sold c. 1875.

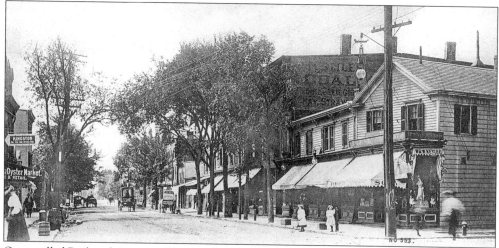

Once called Railroad Avenue, Glenwood Avenue was the road to the first depot of the Newark and Bloomfield Railroad. The lights illuminating the entire corner are the only artificial light on the street except for the gas lamps. The building on the right is Doc Scherff's Drug Store. The containers on the rear counter were for leeches, which were sold in all drugstores in those days. They were used for blood sucking in certain illnesses and for black eyes.

Two

MERCHANTS, MILLS, AND THE MORRIS CANAL

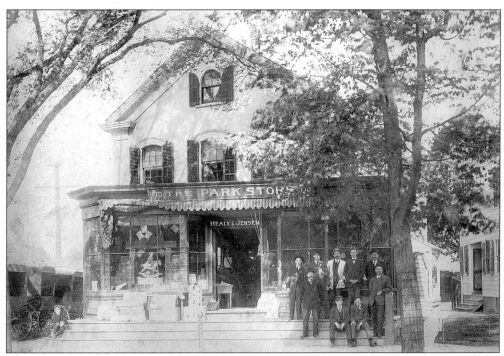

This is Healy and Johnson's Park Store, located at the northwest corner of Broad Street and Belleville Avenue. Arranged alongside the building are the horse-drawn wagons that delivered the groceries around town. Apparently all of the employees went home to put on their Sunday best for this photograph. The store was named for a small slice of the Green that still extends from Belleville Avenue to New Street.

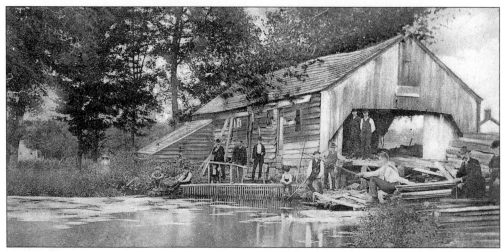

Dodd's Sawmill, located on Glenwood Avenue near Dodd Street, is a part of the town's past. There is no record of when or by whom the first mill was built, but many believe the mill was built in the early 1700s by Linus Dodd. Until its demolition in 1886, the mill remained mostly under the ownership of the Dodd family. Lumber was shipped as far away as California, Europe, and Australia. In 1868, the pond occupied eight acres for the purpose of cutting ice from it in winter.

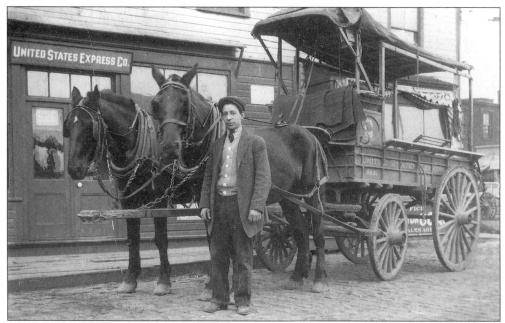

This picture of the United States Express Company's horse-drawn vehicle was taken sometime before the Lackawanna station was elevated and the ramps extended from the porte-cochere to Lackawanna Plaza. A new street was created from the roadbed of the tracks, which had crossed Glenwood Avenue the United States Express Company had an address on Glenwood Avenue, probably in the old station itself. By 1914, it had relocated in the new building. Horse-drawn wagons were common in Bloomfield throughout the 1920s and 1930s. As late as 1950, a horse-drawn milk wagon owned by Becker's Dairy could still be seen plodding along the streets with an oil lantern serving as a taillight, as required by the law.

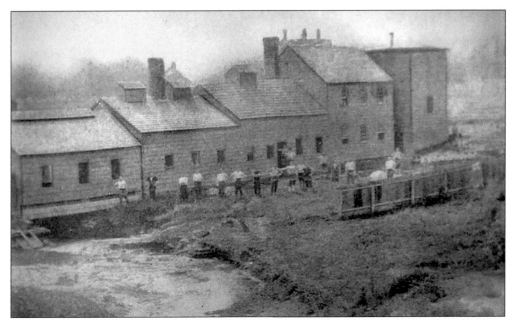

Around 1880, Samuel Ellor, his brother Joseph, and a Mr. Hall started the hat factory at the corner of Prospect and Thornton Streets. For generations, the Ellor family had been hat makers in both England and America. Samuel Ellor followed in the footsteps of his father, William Ellor, who was in the hat manufacturing business and was a partner in the firm of Hampton, Ellor, and Hampson.

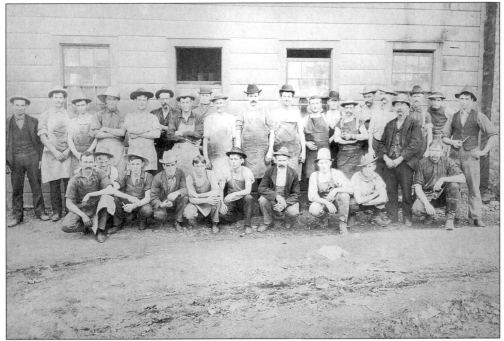

One hundred people were employed in the Ellor hat factory. Most worked on the piecework plan. They bragged that the hat company employees made "about the highest wages of any class of merchants in town."

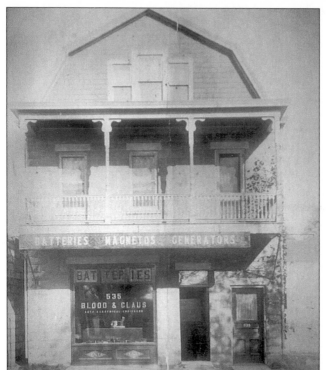

Blood and Klaus, originally a dealer in magnetos and automobile ignition systems, was located at 535 Bloomfield Avenue in the early 1920s, the date of this photograph. Blood and Klaus was one of the first stores in the Center to put a radio set in its window. As television sets were to do 30 years later, this invention stopped traffic on Bloomfield Avenue and made WDKA a household word.

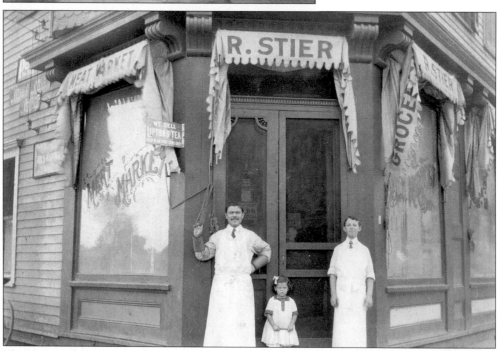

The store at the corner of Linden and Glenwood Avenues had several owners. Shown here is Rubin Stier (left), who operated his meat market at this address, 214 Glenwood Avenue, from 1916 until he moved down the street to No. 294 in 1924. After one year at his new address, he either died or moved elsewhere, as his name vanishes from the town directory.

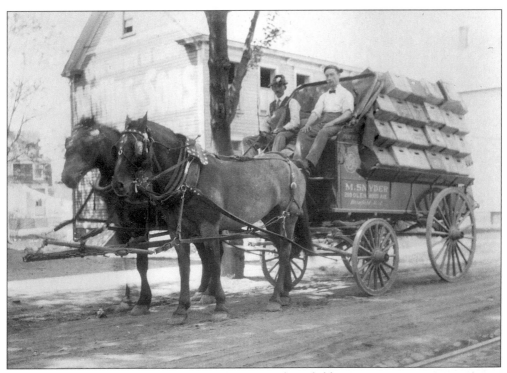

This photograph shows M. Snyder's beer wagon in Bloomfield.

Until *c.* 1924, the same year that the Bloomfield Poultry Culture Club held its first annual poultry show at Community Center, the area north of Bay Avenue was mostly farmland. Fruit trees—such as apple, quince, cherry, plum, and peach—were plentiful. At one time, Brookdale was known for its excellent melons. Wagons filled with melons went down Broad Street and over Bloomfield Avenue on their way to markets in Newark. Fields of beets, carrots, watercress, and other vegetables were raised. The distinctive Brookdale horseradish, introduced by George Fisher, the "horseradish king," was famous. Some residents may remember the Herman Farm on Belleville Avenue. The grocer in this photograph probably sold fruits and vegetables grown on local farms.

The original Oakes Mill building remained on the bank of Oakes Pond until the 1950s, when it was set on fire by Halloween vandals. The pond has been drained and is now the site of Memorial Field.

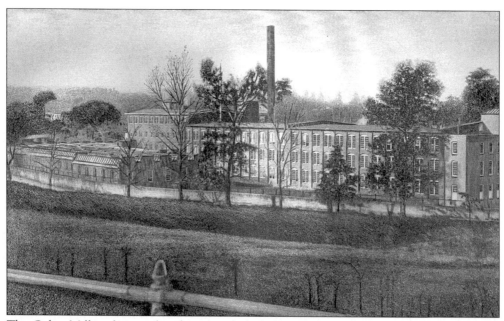

The Oakes Mill at first produced yarn and cloth for country wear. Later it produced tweed, copying a product of the Scottish wool market. Oakes also developed flannels and material for military uniforms during the Civil War. The Oakes Mill provided cloth for 80 percent of the uniforms worn by police departments in the country.

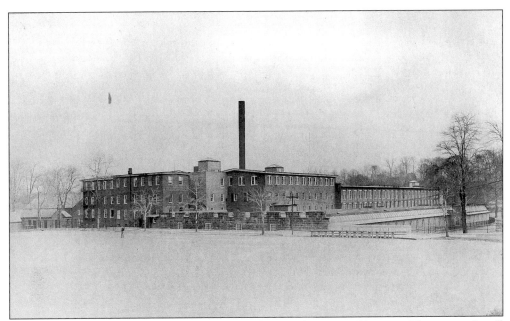

The Oakes Woolen Mills stood on the Third River for over 100 years. The original mill buildings of 1830 were continually enlarged and replaced by brick structures as Oakes cloth became famous throughout the United States for its superior quality. Oakes cloth won prizes at international exhibitions and at the World's Columbian Exposition of 1893. Oakes cloth was selected for Pres. William McKinley's inauguration suit in 1900. The family-owned mill remained active in town until it was sold in 1945.

Born in Bloomfield in 1809, David Oakes established the town's wool industry, which had a major influence for over a century. After serving an apprenticeship in a wool mill in Orange, he started his own mill on the Third River in Bloomfield in 1830. His mill used wool from local sheep to manufacture both yarn and cloth. He began production with one cording machine and four broad hand looms.

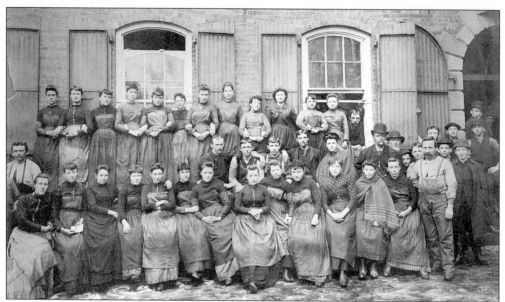

The Oakes Mill manufactured woolens from 1830 until 1945, when the family-owned company was sold to the Crescent Corporation. At that time, the landmark mill employed about 190 workers, but in 1918 there had been 400 employees at the mill, many of them women. A sewing room on the top floor of one of the buildings was reserved for women workers whose job was to mend any tears in the cloth done by the machines.

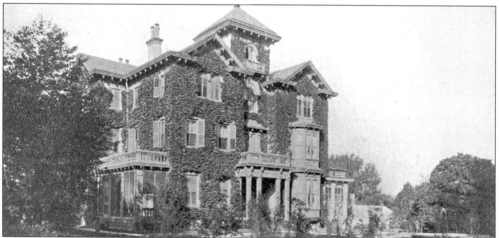

The home of Thomas Oakes II, at 249 Belleville Avenue (formerly New Town Road) was rebuilt in 1878. In keeping with his increasing stature in town, Oakes commissioned an architect (his cousin Joseph Kingsland Oakes) to add a third story and attic to the main block, raise the rear portion to the same height, add a two-story kitchen wing, and heighten the three-story Italianate tower. The tower would then be four stories, making it the tallest structure in Bloomfield at the time. "Oakeside" was set among five acres of beautifully landscaped gardens and manicured lawns, with a greenhouse that provided flowers in winter, a conservatory in the southeast, and a splashing fountain on the site of the original house, which was demolished when the family occupied its new home. The house was demolished between October and December 1943 and is now the site of garden apartments. One reminder of the old house is the brownstone coping bordering the sidewalk in front of where the old house stood.

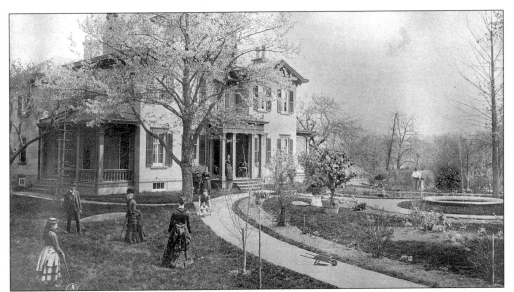

Bloomfield's most impressive house was the David Oakes residence, built in 1853. The design is Italianate, copied from Plate One in Samuel Sloan's book of architectural designs. The construction of the house was substantial, including double-thick brick walls covered with gray stucco and scored into blocks to resemble stone. There were Greek decorative details on the roof of the front porch. Pictured playing a decorous game of croquet in the front yard are, from left to right, Georgia Oakes, Thomas Oakes, Juliet Maxfield Oakes, Helen Van Liew, and George Oakes, the last occupant of the house. The group on the porch are Naomi Baldwin, her sister Rachel Baldwin Oakes, and David Oakes (founder of the Oakes Woolen Mill). Located on five landscaped acres on Belleville Avenue, just east of the Morris Canal, the mansion was demolished in October 1943 and replaced by garden apartments.

In 1830, in a rented mill on the Third River, William B. Davey began making a tough twill fabric called fustian for use in farmers' clothing. In 1842, Davey (who by then owned the mill and considerable property) turned to the manufacture of strong, lightweight pasteboards in demand for use in travelers trunks and as covers for ledgers and albums. Davey's son Edmund assumed responsibility for the mill and, in 1870, modernized and improved the mill. After a fire in 1900, it was rebuilt.

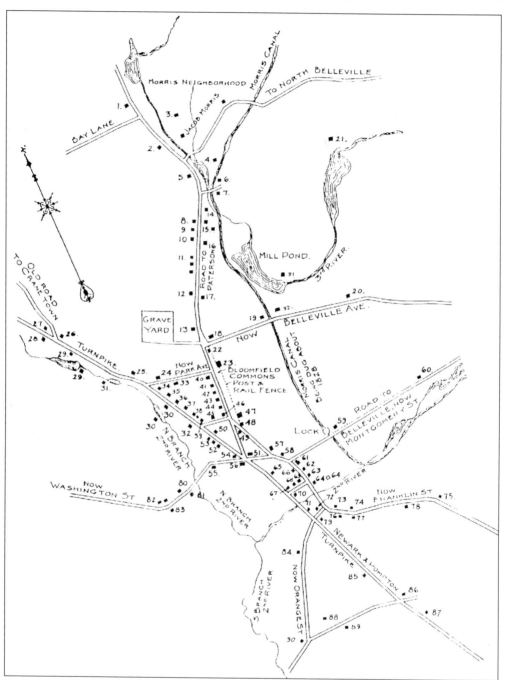

This map was drawn by architect John Capen from information provided by John Oakes. Though it has been reproduced many times, the map contains an error that has gone undetected since its original printing in Folsom's *Bloomfield Old and New*, the centennial history of Bloomfield. No. 21, which Oakes identified as Davey's Fustian Mill, is actually David Oakes Woolen Mill, and the body of water to its left is Oakes Pond. Farther downstream is a second millpond, which is where the Davey Mill should appear. The new reproduction of the Oakes-Capen map has been altered to reflect the proper locations of these two important industries.

42

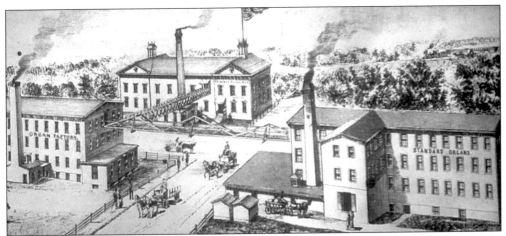

Louis Chabrier Peloubet, born in Philadelphia in 1806, was apprenticed in the art of making musical instruments. When his employer failed, Peloubet bought out the New York business. In 1836, he moved to Bloomfield, occupying part of Pierson's mill at 3 Myrtle Court. From 1837 to 1841, Peloubet made flutes, piccolos, clarinets and other small instruments. In 1842, he moved to 86 Orange Street, where he built his own factory and began to manufacture melodeons and reed organs in elaborately carved wood cases.

The largest industrial firm in town in 1883 was the Peloubet, Pelton Standard Organ Company. Pelton had joined the firm in 1866, leaving c. 1881. The company went out of business in 1890. The c. 1855 Peloubet melodeon in the historical society's museum is in a rosewood case and the c. 1885 Peloubet organ is in a walnut case.

1852.　　　　　　　*1884.*

PELOUBET & COMPANY,

— MANUFACTURERS OF THE —

CELEBRATED

STANDARD ORGAN.　REED-PIPE ORGAN.

In All Styles for Parlor, School, Church and Chapel Use.

120,000 IN DAILY USE.

Every Organ fully Warranted for Five Years.

If you want an organ, don't fail to test the "Standard" before buying elsewhere. If there is no agent in your locality, write for prices and styles to

Peloubet & Company,

BLOOMFIELD, **NEW JERSEY.**

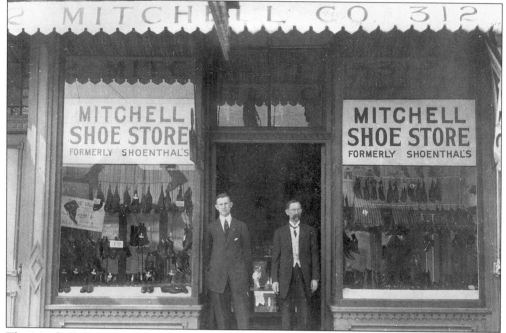

The Mitchell shoe store was located on the first floor of 306 Glenwood Avenue in what was then known as Unangst hall. The building was used as a meeting place for lodges and other fraternal organizations before Milton Unangst contracted Charles M. Lockwood to completely rebuild and enlarge the structure in 1890. The ornate balconies on the front were removed during remodeling and Mitchell Shoes moved elsewhere. The hall was on the property contiguous with Unangst's residence on Washington Street and may have originated as an outbuilding for the Washington Street estate. Still standing today, the original structure is around 120 years old.

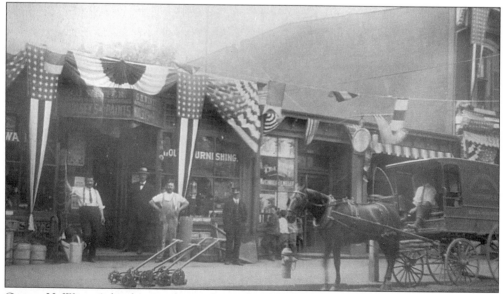

George H. Winter's hardware store was located at 298 Glenwood Avenue. In this photograph, the store is probably decorated for Bloomfield's centennial in 1912.

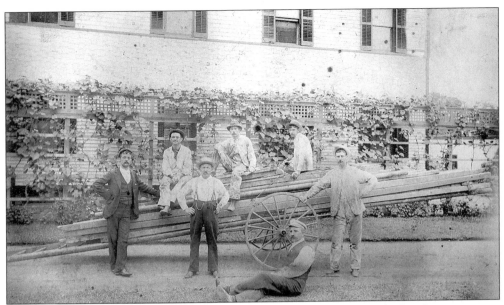

George Peterson lived with his wife, Anna, at 20 Peloubet Street. Peloubet Street was one block long, running from Orange Street to the tracks of the Delaware, Lackawanna, and Western Railroad. The street was named for the Peloubet Organ Company, long out of business when Peterson and his son-in-law Fred J. Dahl started their painting business. Martins Brush Factory shared the block with the Petersons, while the Ampere Silk Mill stood a few doors to the west. This photograph shows George Peterson and his painting crew.

Edward Heckel embarked in the wholesale calf-dressing business on Whiskey Lane, now Grove Street. In 1876, he opened a shop at 551 Bloomfield Avenue in conjunction with his farm, which was on Black Pond, now Franklin Street. After many years at 9 Broad Street, the business moved to 40 Broad Street. The Heckel sons recalled that during the blizzard of 1888, their store alone was able to supply the townspeople. This picture was obviously taken in August when a bumper crop of watermelons from Bloomfield farms was available to cool parched throats.

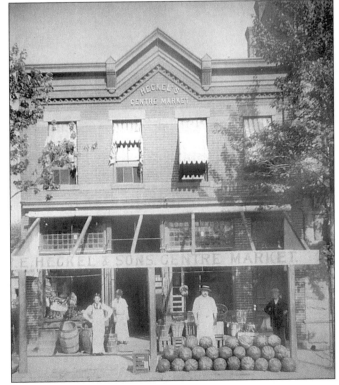

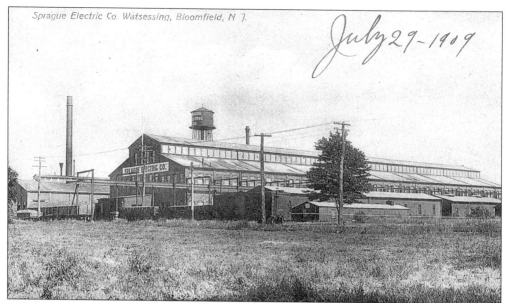

July 29–1909

This 1919 postcard shows the Sprague Electric Company, which stood in the Watsessing section among open fields. By 1918, the company had become part of General Electric, which built a large six-story steel-framed building on the Lawrence Street side of this old building. Although General Electric left town in 1959, both buildings remain standing.

With the advent of more modern transportation, the Morris Canal was abandoned. The canal's owners, the Lehigh Coal and Navigation Company, decided to open a yard in this area where their famous longer lasting coal had previously been barged. Formed in 1932, the new company was named the Canal Coal Company after the extinct waterway. Its president, John E. Dale, was a former Bloomfield High School athlete. The Canal Coal Company would now be located right in the middle of the Garden State Parkway.

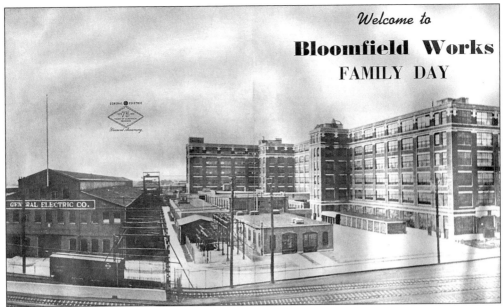

When the Sprague Electric Company merged with General Electric in 1902, the company started developing its location. The plant eventually grew to include 17 buildings covering an area of about 15 city blocks and employing 2,000 people. In the early days, the plant produced industrial controls, mechanical hoists, automatic railroad switches, rheostats, and telephone switchboards.

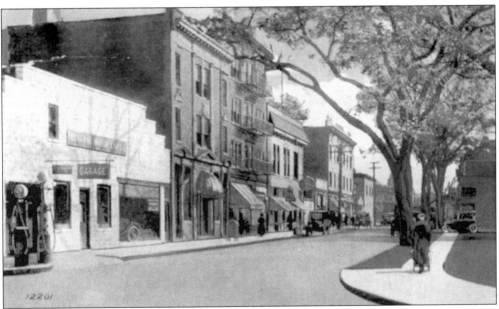

The Bloomfield council of the James T. Boyd Junior Order of the United American Mechanics, organized in November 1896, was the largest fraternal organization in town, with a membership of 950. It met in its own building, which is still standing at 69–71 Washington Street. The organization was particularly interested in promoting patriotism among school children. The order maintained one of the best bands in the vicinity and won several championships in baseball and bowling. It was active as late as 1932 but no longer exists.

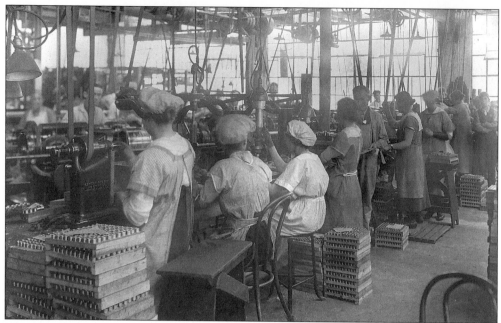

Begun in Bloomfield in 1915, the International Arms and Fuze Company became one of the largest munitions factories in the world. The plant was built on Bloomfield Avenue and Grove Street and at its busiest employed 10,000 workers. The powder used in the manufacturing of fuses was stored on Crow Hill, now the site of the Forest Hill Golf Club. The finished product, live ammunition, was shipped via the Orange branch of the Erie Railroad to Hoboken and then on to Europe. After the war, the plant was used briefly by the Bakelite Company, then the Star Electric Company, and finally the Charms Candy Company. This photograph shows women workers of the International Arms and Fuze Company.

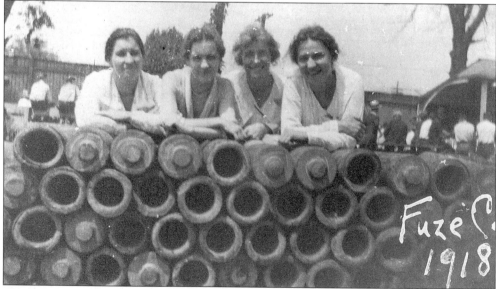

These female workers from the International Arms and Fuze Company got a taste of freedom and the thrill of getting their very own pay envelope. They could earn as much as $35 for only a 10-hour day.

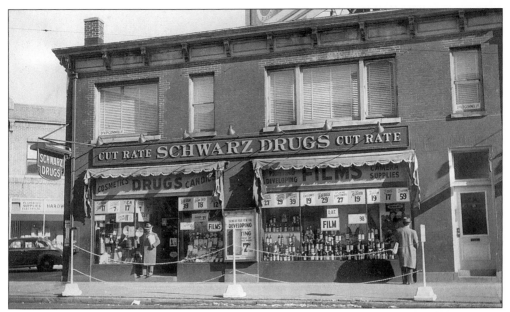

Schwarz Drugs, located at Bloomfield Avenue and Washington Street, was housed on property that belonged to John Henry "Doc" Cadmus during Civil War times. Doc Cadmus conducted a newspaper, stationery, and toy store. Fishing tackle was one of the store's specialties, and New York vacationers who stayed in town during the summers were steady customers.

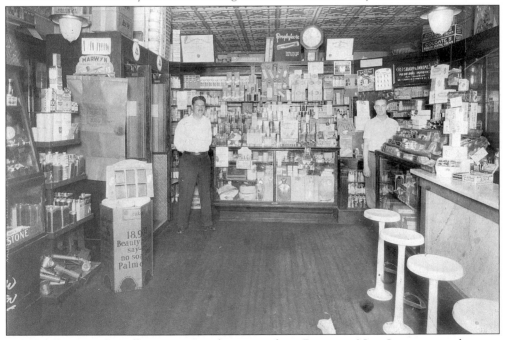

In 1927, Maurice Swerdlow, a young pharmacist from Bayonne, New Jersey, opened a new drugstore at 103 Montgomery Street. Swerdlow, pictured at left with an unidentified friend, was nicknamed "Doc" for his kindness toward the dogs and cats injured in the increasing automobile traffic on busy Montgomery Street. His wife, Sadie, helped run the drugstore and also served as a substitute teacher at the nearby Fairview School. (Courtesy of Joan Swerdlow Millman.)

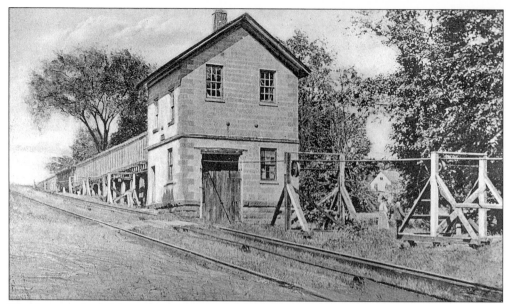

The flume to the left brought water from the top of the plane into the stone turbine house. The water dropped under the turbine, causing it to revolve and pull the boats up and down the plane. At the time, it was considered one of the Seven Wonders of the Modern World.

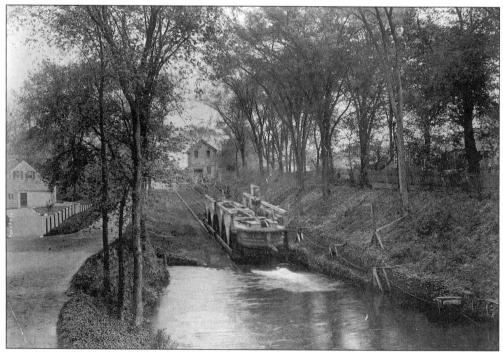

One of the canal's 23 incline planes and 24 locks was located on Hoover Avenue. In their day, incline planes were the ultimate in modern mechanical ingenuity. Powered by a water turbine wheel and using wheeled cradles, the Bloomfield incline would lift a 30-ton boat, including cargo and passengers, up a grade several hundred feet long to the canal, 60 feet higher than the starting point. The entire canal traveled 103 miles between the Hudson and Delaware Rivers.

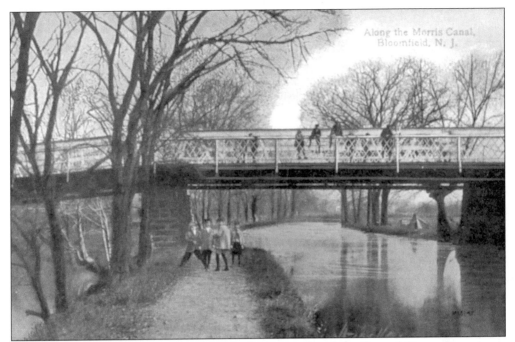

The bridge at Berkeley Avenue spanned both the canal and the Second River. Once, in an effort to speed transportation, a gasoline-powered boat was put on the canal; however, any boat moving faster than five miles per hour in the narrow channel created a swell of water ahead of the boat, causing it to settle to the bottom. In this photograph of the Berkeley Avenue bridge, the Morris Canal and Wright's field are on the right and the Second River is on the left.

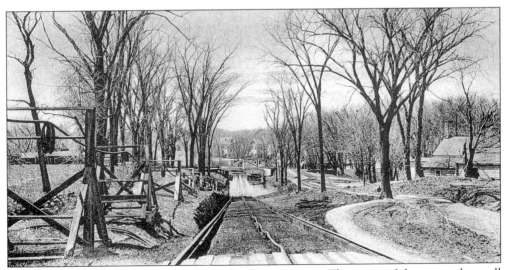

Incline plane No. 11 was located just north of James Street. The gauge of the iron rails on all planes was 12.5 feet between the rails. Plane operators received $25 per month, the highest salary of any canal employee. Kennedy Drive was built on the site of this plane in 1953. Present-day motorists travel the same incline when driving from Belleville Avenue north to Hoover Avenue.

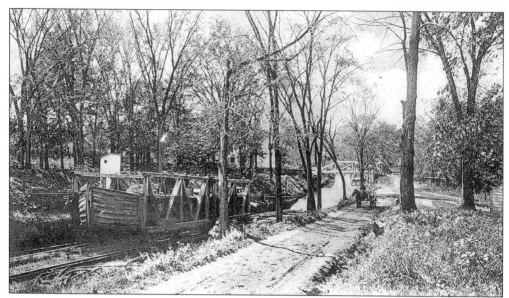

In its course across New Jersey, the canal climbed a total height of 914 feet through the use of conventional locks and incline planes. Each incline plane provided a change in elevation of more than 20 feet. All 23 incline planes were built from designs made by Ephraim Morris in his mill located at Bay Avenue and Morris Place. Ephraim Morris was also the general manager of the canal from 1832 to 1848. The incline plane at Baldwin Street is pictured here.

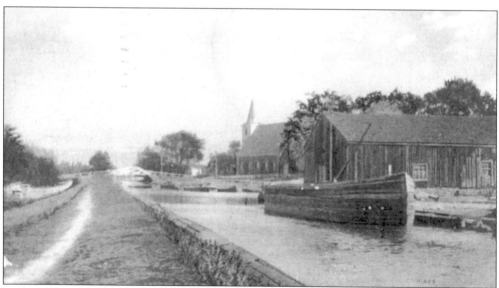

Because planes and locks operated only between sunrise on Monday and midnight the following Saturday, canal workers were idle on Sunday. From 1860 to 1870, Nason B. Collins, a local blacksmith, conducted services of worship under some beech trees at the side of the canal. Later a canvas tent sheltered the congregation. In 1871, Hope Chapel, a mission of the Presbyterian church, was erected at that spot. The small building became vacant in 1888, when the Hope Chapel congregation built a new church at the corner of Broughton and Bay Avenues. The old building became the first home of St. Valentine's Church, seen here in the photograph.

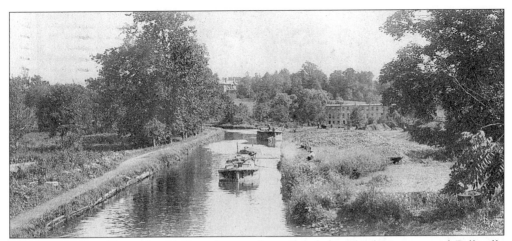

After negotiating Plane No. 11 East, the canal paralleled the Third River toward Belleville Avenue. The buildings in the right background are probably those of the Oakes Woolen Mill. Oakes Pond would be considerably below the level of the canal to the left. That is now the site of Foley Field.

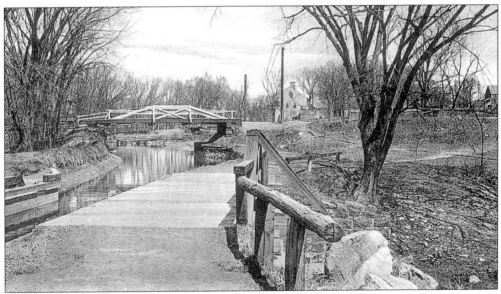

The canal is seen here crossing the Second River aqueduct. In an attempt to have passenger transportation via the canal, a boat drawn by three horses made daily trips between Newark and Passaic. The fare from Bloomfield to Newark was 25¢. In contrast to the railroad, the canal trip was very quiet but slow. Travelers seemed to prefer speed, thus putting an end to passenger traffic on the canal.

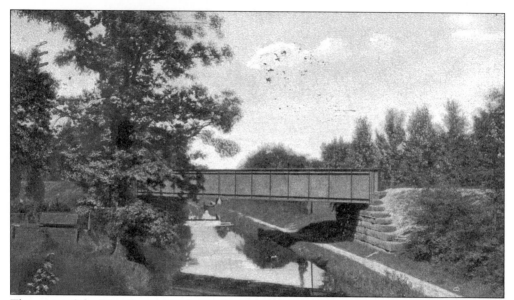

This view of the Morris canal looks south toward the Erie Railroad bridge. The Morris Canal was opened in 1832 and for 50 years was the principal carrier of coal from the Pennsylvania mines to metropolitan areas in New Jersey and New York. By the early 1900s, however, railroads were doing the same job faster and cheaper and canal traffic had dwindled to Sunday outings in canoes. The canal was officially abandoned in 1924.

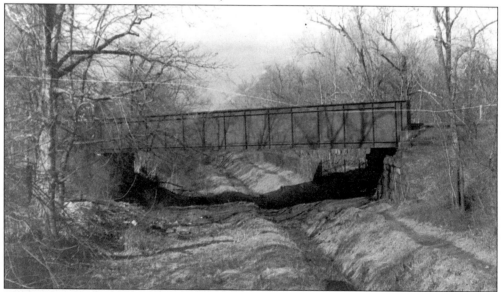

This canal view is directed south toward the Erie Railroad bridge in 1949. For 20 years after it was drained, the canal bed was a weed-filled ditch. The town purchased the property between the Belleville and Clifton borders, paying $5,000 for a strip of land 5 miles long and 60 feet wide, but had no plans for its use. Extending the city subway system from Belleville was proposed but not carried out due to the economic conditions of the 1930s. In 1954, the town constructed a road in the bed of the Morris Canal. The road traveled in the canal bed from Belleville Avenue to James Street. It continued another quarter of a mile from James Street to Hoover Avenue, where it connected East Passaic Avenue to West Passaic Avenue.

Visitors to Bloomfield in 1832 described the canal as very beautiful, with views of farms, trees on either side, and waterlillies and wildflowers along the bank. This view looks north from Belleville Avenue. (Photograph by Herbert N. Schneider.)

Looking south, this view shows the canal from Belleville Avenue. (Photograph by Herbert N. Schneider.)

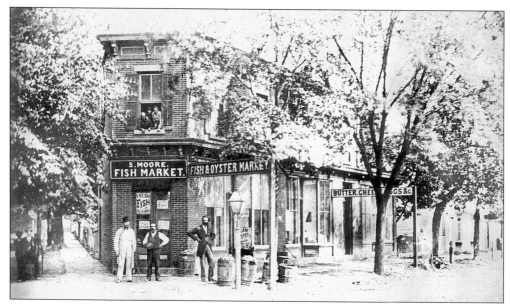

The original of this photograph is plainly identified as "Samuel Moore's Fish Market, 1893." However, the date could possibly be as early as 1865 because the clothing of the man in front of the store (possibly Moore himself) is of the pre–Civil War period. Also, none of the Bloomfield newspapers of the 1870s, 1880s, or 1890s mention Samuel Moore or his fish market, although it occupied a prominent site at the corner of Washington Street and Bloomfield Avenue. In the 1890s, the second floor was rented by Vollmer's Photography Studio. Although Vollmer's establishment is often mentioned in contemporary newspapers, Samuel Moore and his market are conspicuously absent. The building served as the home of the Schwarz Drugs until after World War II. It was later demolished and replaced by the structure that still occupies that corner.

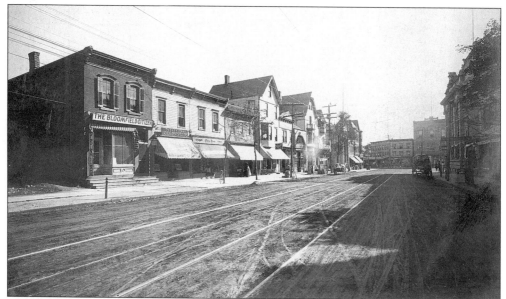

This view of Broad Street in October 1911 shows the office of the town's weekly newspaper, the *Bloomfield Citizen*.

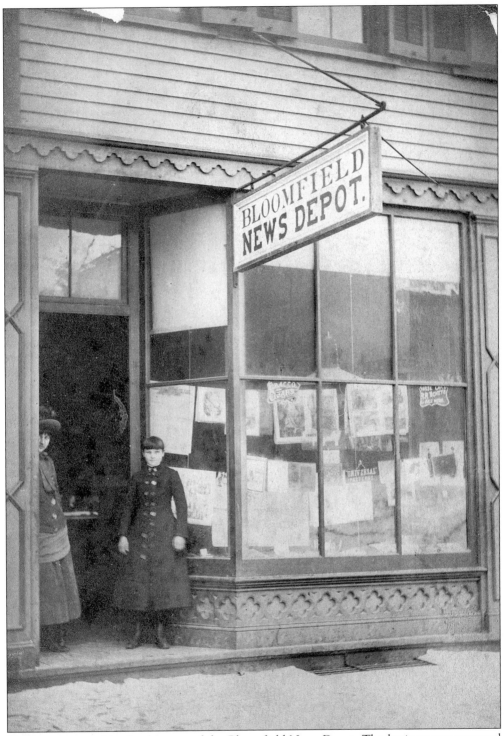

Two women stand in the doorway of the Bloomfield News Depot. The business was operated by Glennon and Smith at 28 Broad Street. Later, John Moran purchased the building and modernized it in the Art Deco style, and it became a stationery store.

Started in 1935, General Electric's sprawling air conditioner plant on Lawrence Street became a prominent presence in the town's industrial district. To meet the growing demands of the air-conditioning business, modernization and renovation was completed in 1955. Pictured here is the General Electric Fire Department. Captain Sturtevant is in the front row, fourth from the left; seventh from left is Louis Gass; George West is in the middle row, fourth from the left; and Joseph Bice is sixth from the left in the back row.

War work at General Electric increased steadily in the 1940s. In its Arlington Avenue plant, General Electric made mechanisms for B-29 turrets and searchlights. The company took a leading role in the community, participating in many civic fundraising campaigns and activities until it left Bloomfield in the 1960s. Posing in 1929 are General Electric tool and die workers. Fifth from the left in the front row is Mr. Hans, and seventh from the left is Jimmy Laren. In the third row, the fifth man from the left is Louis Gass.

This photograph shows about 62 men from the Jenkins Manufacturing Company on an outing far down Bloomfield Avenue at Pine Brook in 1922. The group brought along their own entertainment: an accordion, drums, trumpet, and a banjo. They seemed determined to enjoy themselves and relax, despite coats, vests, and stiff collars.

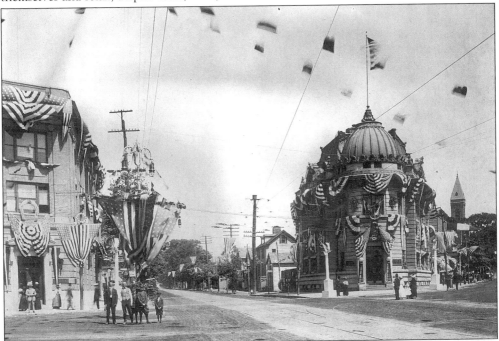

The domed bank at the Center, shown here decorated for the 1912 centennial, seemed to symbolize the town of Bloomfield as no other structure did (there was no town hall until 1927). Standing at the most prominent corner of Bloomfield and Glenwood Avenues and Washington and Broad Streets, the building was part of the townscape for less than 30 years. It appeared on many postcards and seemed adequate for the needs of the bank until the 1920s, when a merger with the Bloomfield Trust Company across the street demanded a larger structure, with the added benefit of six floors of rent-paying tenants at the prestigious address of 2 Broad Street.

59

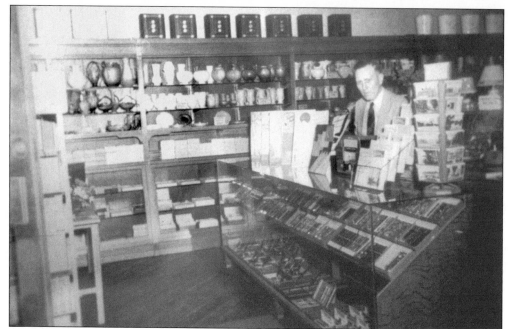

In 1913, John Moran founded his first store at 16 Broad Street. When a fire necessitated a move, Moran reestablished his thriving business at 28 Broad Street. In 1938, the 25th anniversary of the store, modernization of the storefront was completed. When John Moran passed away in 1946, his wife acquired property and expanded to make Moran's Greeting Headquarters in Suburban Essex.

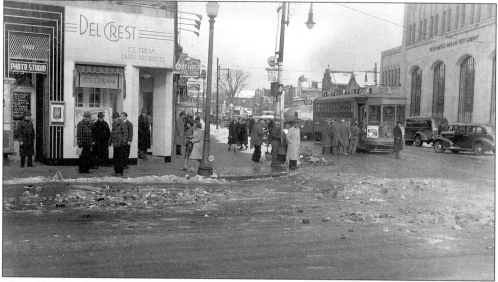

The old Bloomfield Trust Company space, vacant for a few years after the company's their merger with the Bloomfield National Bank, became the site of DelCrest. Known for its huge, 5¢ ice-cream cones, DelCrest was very popular while it lasted but, by the 1940s, it had been displaced by the Borden Bowl. Now the Bloomfield Trust Company space has been divided up into small stores. Once in a while, when the space on the corner either moves or goes out of business and their sign comes down, the DelCrest logo once again looks out over the Center.

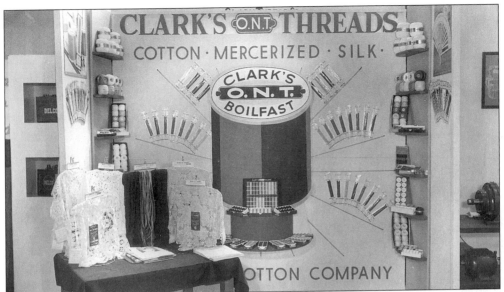

In 1922, the Clark Thread Company purchased a large tract of land along the Yantacaw. It ran from a few hundred feet north of Bay Avenue over to Yantacaw Avenue. The original plant was located in East Newark, and the Bloomfield site was selected because of the pure water obtained from the streams and springs. The Bloomfield plant was enlarged several times. Clark's devised a six-cord thread that was suitable for both hand and machine work. It was known as Clark's Our New Thread, but this title was later condensed to ONT and became the Clark trademark. In 1949, the Clark Thread Company left Bloomfield.

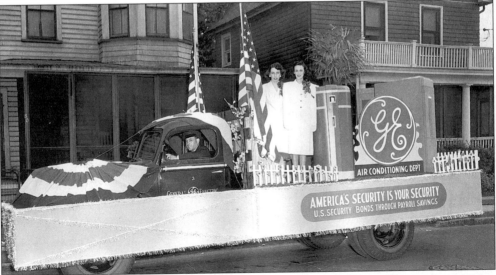

During World War II, General Electric participated enthusiastically in all patriotic activities, including War Bond drives. This float, from a parade held during or just before the war, shows General Electric employees Henry Campanelli (driver), Edith Cool, and Betty Cronnick. As one of the most important industries in town, General Electric shared the Watsessing area with the Wiggins Company, Westinghouse Lamp Division (Bloomfield's largest plant), Scott and Bowne, and the Schering Corporation. With the exception of the 1918 General Electric building, all of the others have been demolished.

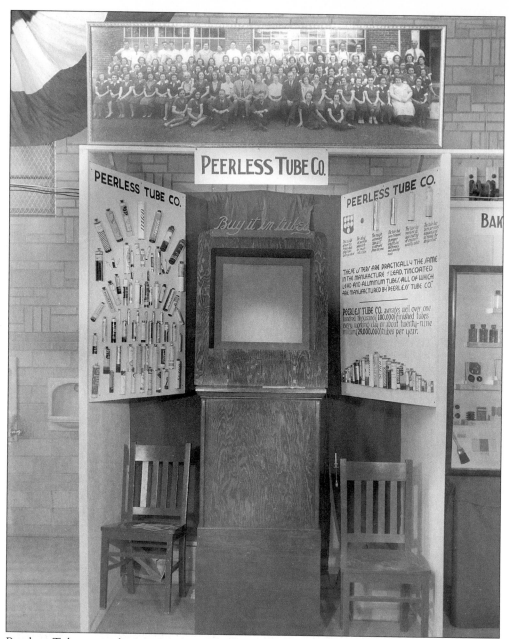

Peerless Tube, a packaging pioneer, has operated its Bloomfield plant on Locust Avenue continuously since 1912, making Peerless one of Bloomfield's oldest industrial companies.

Peerless is a major supplier of everyday tubes that hold anything from toothpaste, to glue, to shaving cream. In the early 1950s, Frederick Remington, president of Peerless, foresaw that push-button aerosol containers would be in wide demand and prepared the company to become a consistently successful producer of this growing industry. Peerless Tube's product is unique due to its engineering and research know-how. Frederick Remington's son Frederick Remington Jr. is currently serving as president of the company. This photograph displays Peerless products in an industrial exhibit held in South Junior High School shortly after the school opened.

Three

CIVIC PRIDE

Bloomfield's centennial celebration, on June 11, 1912, was a great success. All of its outstanding events were admired and cheered by thousands of visitors. In addition to the unveiling of the Soldiers and Sailors Monument, a military and firemen's parade (led by Civil War veteran George W. Cadmus) thrilled the crowds gathered on the parade route.

Thomas A. Edison is seen here with Rev. Frederick George Willie of Park Methodist Church on June 23, 1929, the day of the dedication of the church. The great inventor personally installed the church's electrical system. A close look will reveal that the absent-minded inventor was wearing slippers instead of shoes. Bloomfield citizen Frank Sprague was a former assistant to Thomas Edison. In 1892, Sprague used a section of the Watsessing area to build a plant to manufacture a system of multiple-unit electric train controls.

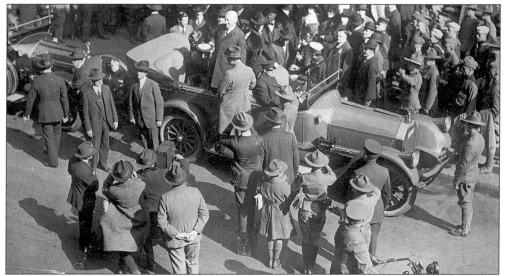

Pres. Woodrow Wilson is shown visiting Bloomfield during World War I. The town has also been honored by the visits of other political notables. In January 1915, former President Taft gave an impressive lecture at the church on the Green. In 1968, candidate Richard Nixon came to town while campaigning for his second term. Ronald Reagan visited the town hall in June 1985. In September 1988, after an appearance at the Annin Flag Company at 88 Llewellyn Avenue, Republican presidential candidate George Bush paid a visit to the Glenwood Diner.

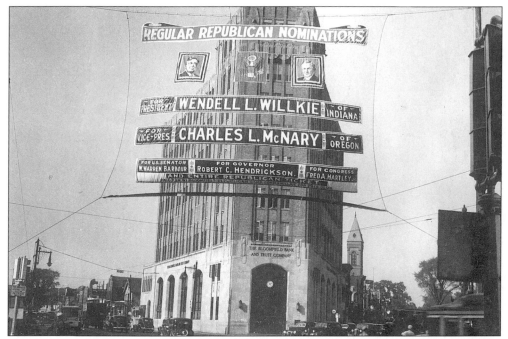

Bloomfield Republicans spread this banner across Bloomfield Center during the 1940 presidential election. The public service charge for the poles was $80 and the cost of the banner was over $400. The banner was impressive but did not get Wilkie elected. Franklin Delano Roosevelt carried the day.

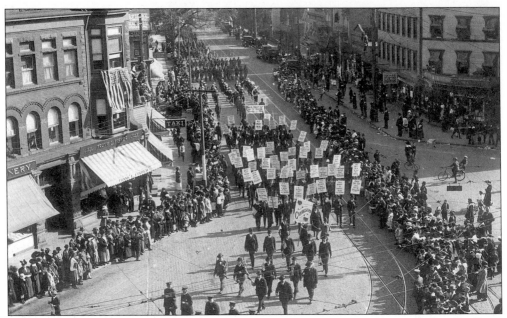

The year 1917 opened with the certainty that the country was going to be involved in the Great War, and a wave of preparation began to sweep the country. In Bloomfield, the initial step was to organize a Red Cross chapter at a meeting in the First Presbyterian Church parish house.

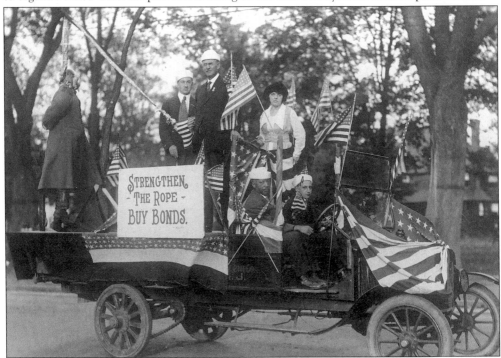

On June 18, 1917, the first Liberty Loan campaign was launched. Town subscriptions exceeded $600,000. On October 1, the second Liberty Loan campaign was organized with Allison Dodd as chairman and town subscriptions amounted to more than $1.3 million. War stamp sales were organized at the end of the year with Edward F. Higgins, the postmaster, chairing the effort.

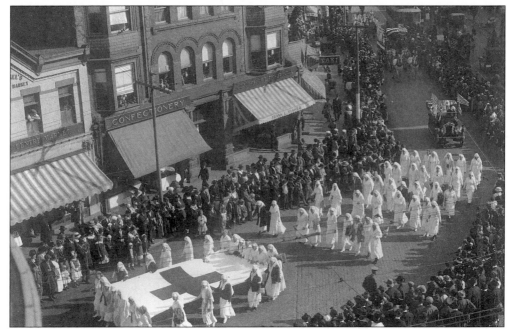

The Red Cross parade, held to inaugurate the Red Cross War Fund Drive in May 1918, was one of the greatest street pageants ever witnessed in town. Mayor Frederick Sadler issued a proclamation requesting that patriotic colors be displayed on parade day. The parade formed at Bloomfield and Watsessing Avenues and proceeded to Watsessing Center, Orange Street, Franklin Street, Washington Street, the Center, and Broad Street, ending at the high school. John A. Moran was chairman of the parade committee.

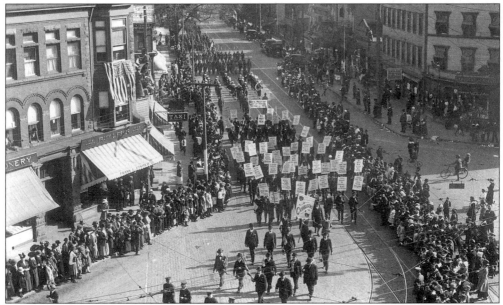

A great feature of the parade was the part played by the town's industries and their employees. International Arms and Fuze, Sprague Electric, Consolidated Pin, Jenkins, Davey, Westinghouse Lamp Company, Edison Manufacturing, and others drew praise for the showing they made. Contributions reached $93,150.

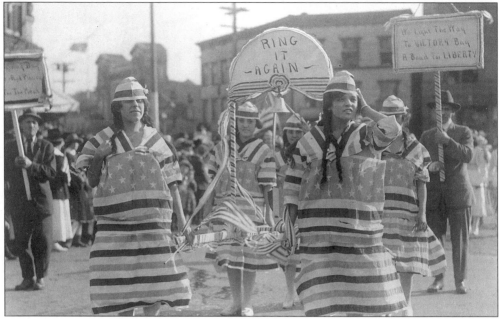

Bloomfield public school children, Sacred Heart School students, the Sacred Heart Fife and Drum Corps, and students at the Bloomfield Theological Seminary drew cheers and applause from the spirited onlookers as the marchers and decorated floats went by.

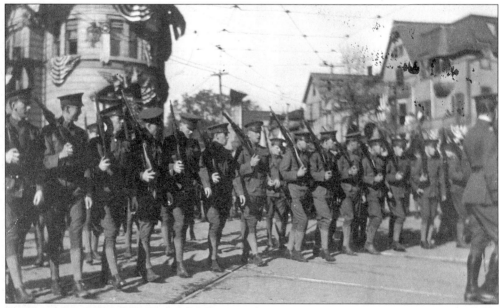

Company B of the Fifth Battalion State Militia, Company A of the Military Reserves, Company B of the Home Guard, the Bloomfield Fire Department, letter carriers, Boy Scouts, and the Boy Scouts Fife and Drum Corps all marched in the 1918 parade. A 60-piece sailors' band from Pelham Bay arrived on the Lackawanna train to participate in the parade. They were honored with a luncheon served at the First Presbyterian Church and were invited to relax at the Catholic Lyceum following the festivities. This photograph shows soldiers in front of the Bloomfield National Bank.

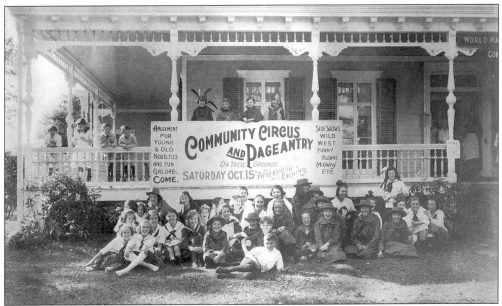

At the end of World War I, Mayor Frederick Sadler and a committee of townspeople favored opening a community house to honor the patriotic service of more than 1,000 of the town's sons and daughters. A successful campaign for funds enabled the town to purchase Judge Amzi Dodd's home at 82 Broad Street. The community house formally opened with an enthusiastic county fair, carnival, and Gypsy Frolic on September 22, 1920.

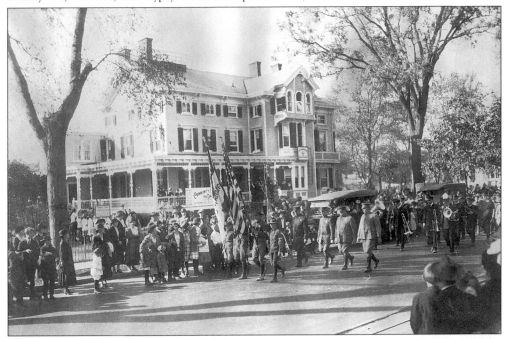

These soldiers are marching in front of the community house. Many organizations—such the Red Cross, American Legion, Women's Club, Boy Scouts, and the League for Friendly Service—held meetings at the community house. Games and a story hour for children were scheduled for Saturday mornings.

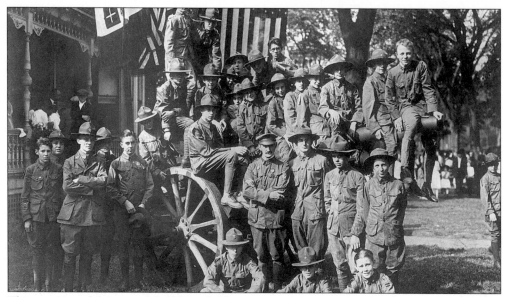

The opening celebration of the Bloomfield war memorial community house was a great popular success in September 1920. The presence of soldiers and the artillery maneuvers of a tractor squadron from Battery A gave a touch of military color to the event. That October, the Bloomfield war memorial tablet committee began raising funds among the town schoolchildren. The bronze tablet, inscribed with the name of every man who served in the war and died in service, was presented on Armistice Day 1921 and was placed in the community house. Today the tablet is displayed in the Veterans Lounge of the Civic Center.

The Yantacaw Gypsy Clan from Brookdale, with Queen Harriet Morrison and her attendants, arrived at the community house to open the Gypsy Frolic. The queen's chariot was decorated and drawn by calico horses. Huge crowds were entertained by a parade, craft booths, Vaudeville acts, and fortune-tellers. The DAR was in charge of the tearoom and anyone having a pony to lend for the afternoon was asked to contact Mrs. Wyman of Warren Street. A *Gypsy Pageant*, written by Elizabeth Edland, was performed in the evening on the brightly illuminated Green.

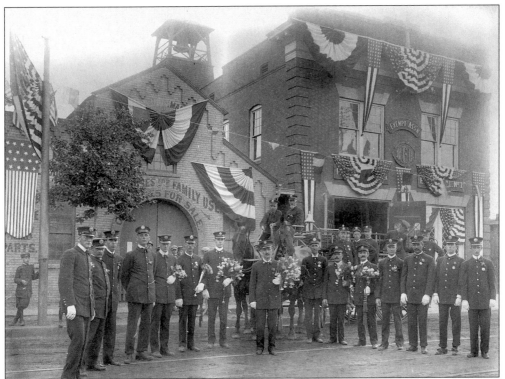

Fully decorated for Bloomfield's centennial parade in 1912, this old firehouse stood on Bloomfield Avenue near the site of the Royal Theater. The bell shown in the tower is now located on the lawn of the municipal building.

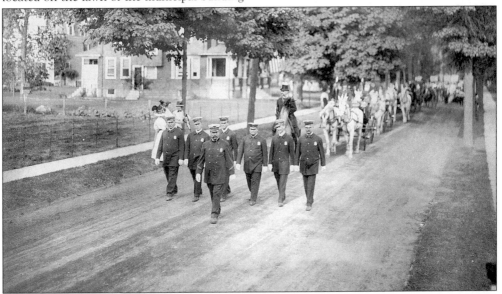

The Bloomfield Police Department proudly parades westward on Beach Street in this 1910 photograph. Leading the contingent is Louis M. Collins, department chief from 1900 to 1927. The house in the left background, No. 99, was occupied by Arnold W. Fismer. He is no longer in residence, but the house is still there.

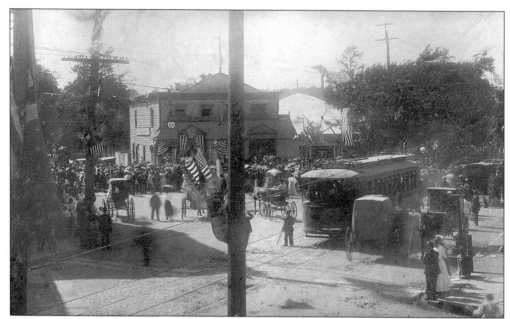

Shown is an early-20th-century firemen's celebration. The picture was taken by Henry Vollmer through a window in his studio on the second floor of the old Schwarz Drugs, at the intersection of Bloomfield Avenue and Washington Street. Culhane's store stands on the corner to the left. Since everyone seems to be heading toward the large tent in the background, it is most likely the location of the afternoon's activities. All of the vehicles are horse-drawn. (See another photograph of this same occasion on page 4.)

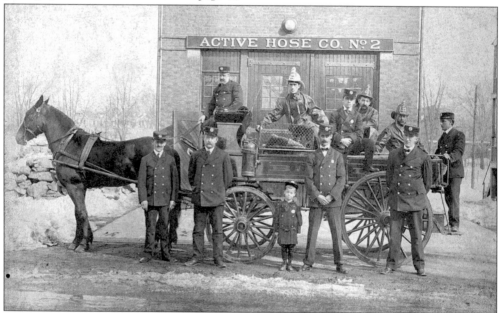

This 1907 portrait shows the men of Active Hose Company No. 2, which stood on Orange Street in the Watsessing section. It remained there until the 1970s, when it was replaced by a new firehouse on Watsessing Avenue. The site and the street itself are now part of the Home Depot parking lot.

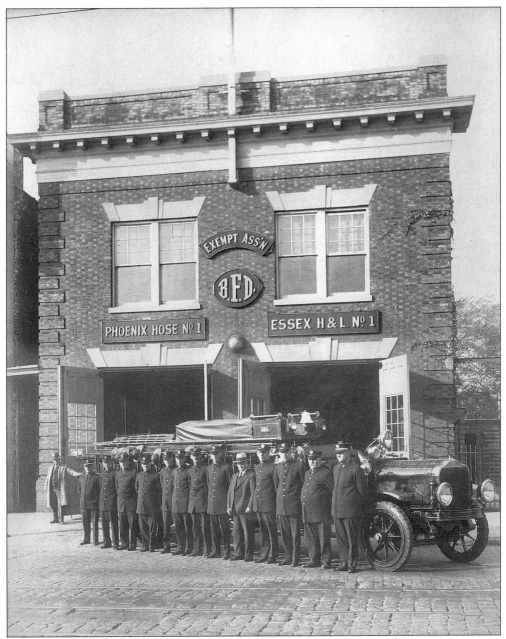

Phoenix Hose Company No. 1 shared this building on Bloomfield Avenue with Essex Hook and Ladder No. 1 when the latter abandoned its original location on Glenwood Avenue near the railroad crossing. This 1929 photograph shows the new motorized equipment with the firemen lined up in front.

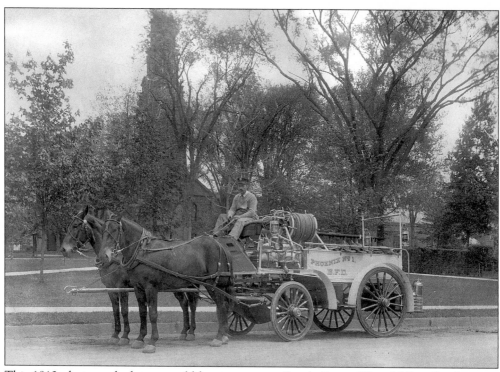

This 1912 photograph shows an old hose wagon on Beach Street. The old First Presbyterian Church and parish house are in the background. Note the fire extinguisher, tanks, lanterns, mudguards, hose reel, and steps. The man in the driver's seat is Archie Heath, who became chief of the fire department in 1937.

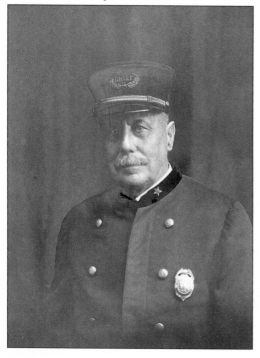

From the group of 122 officers who constitute the police force today, it is a long way back to the three policemen who, in 1903, were the Bloomfield Police Department. The three original regular policemen were Louis M. Collins, Thomas McKane, and James Foster. Collins, shown here, was chief of police and held the position until he retired in 1923. He later became a member of the town council.

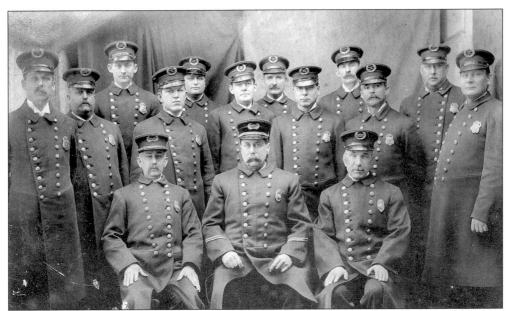

Prior to the establishment of a regular police force, citizens were protected by constables. In 1900, there were several saloons in the town's central area. As the population increased, several clashes prompted the constables to do police duty on Saturday nights and Sundays. The constables conducted their business in citizens' clothing and few arrests were made except with warrants from a justice of the peace. Seymour P. Gilbert, a councilman and chairman of the police committee, promoted the idea of improving police service by having the constables wear uniforms while on town police duty.

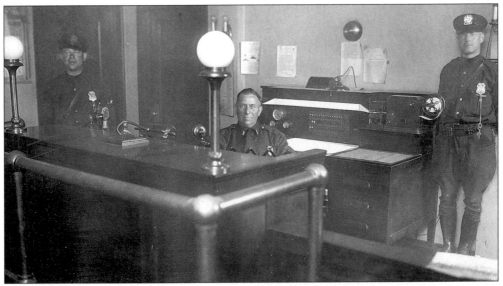

Calls made from a police call box, located on the street, were answered at the Gamewell equipment by the officer on duty.

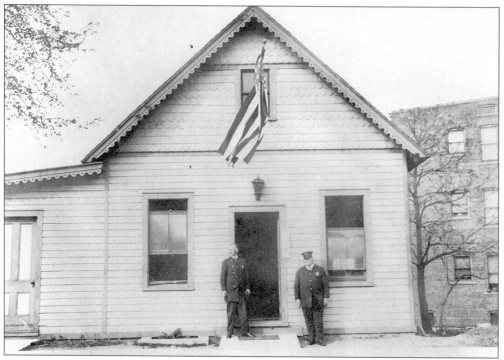

By 1928, the police force had grown from 3 to 54 men. As additional men were added to the department, a police station was built on Conger Street, near Glenwood Avenue. This photograph shows Officer Bayliss and Officer Belfi at the Conger Street station.

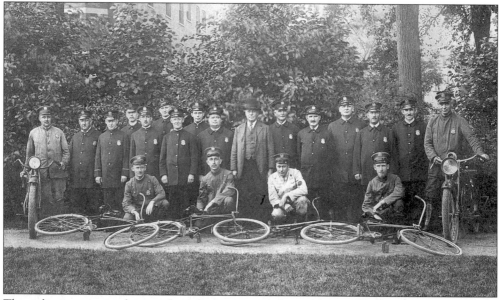

The policemen posing here on bicycles are, from left to right, as follows: (front row) Grover O'Neill, Carl Jensen, Tom Clancy, and Clifford Shipman; (back row) George Collins, John Marshall, John Degnan, Matthew Maquail, Arthur Wilhelm, John Whelan, Robert Foster, John Barry, Anthony Belfi, Louis Collins, Thomas McKane, Thomas Moran, John Blum, Wallace Tappin, Walter O'Neill, and Stan Stocko.

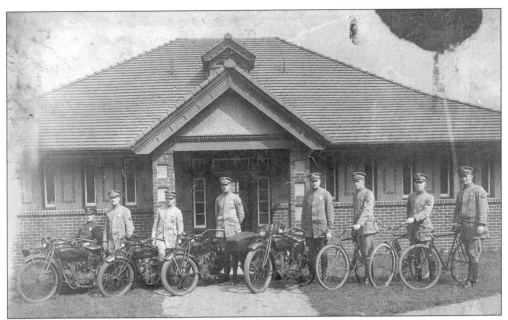

Early in Chief Louis M. Collins's administration, policemen were provided with bicycles to overtake speeding automobiles. Later, the bicycles were replaced with motorcycles and, by 1928, the department had three cars and five motorcycles. The cars were used to police the town through the night, and the motorcycles were still used to catch speeders. The officers pictured here are, from left to right, John Borcher, Carl Brentz, Stanley Trebilock, Charles Hanily, John Whelan, Arthur Oswald, Edward Ferguson, and Grover O'Neill.

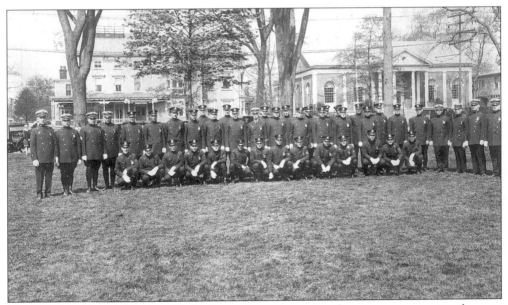

This *c.* 1927 photograph most likely shows the entire police department, posing on the west side of the Green. In the right background stands the new library built in the Georgian style by John F. Capen. To the left is the residence of Judge Amzi Dodd, which became the community house after World War I. Today, the library esplanade occupies the site.

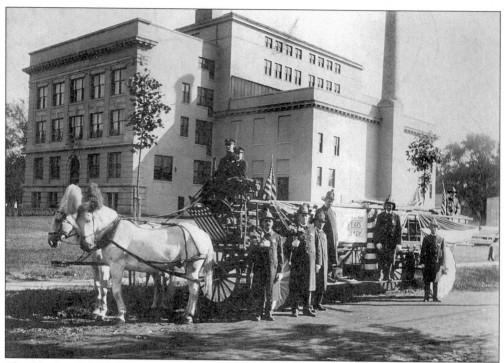

The fire department poses on the State Street side of the new high school shortly after the building was completed in 1912. This photograph provides a rare view of the school. The auditorium projecting from the center and the three sides of the area above the skylight were hidden from view by a 1920 addition. The addition exactly matched the architecture of the earlier portion, giving the impression that it had always been a single structure.

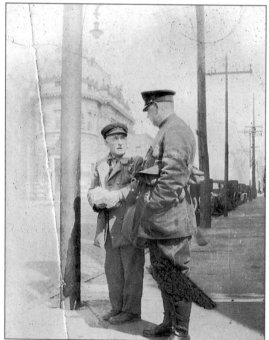

In this 1920s snapshot, looking north on Broad Street from Bloomfield Avenue, patrolman Richard T. Gorman exchanges greetings with letter carrier William Hall. To the left is the French Second Empire–style bank that graced the Center from 1902 until 1929. Gorman's usual station was on Prospect Street at the Watsessing School. Born in Ossining, New York, c. 1888, Gorman came to Bloomfield in 1904. He worked for Edison Manufacturing in West Orange as a steamfitter and, in 1930, joined the Bloomfield Police Department, serving for 26 years. He and his wife, Elsie Franck Gorman, raised their family on Willow Street. He was active as a semiprofessional football player and served as PBA vice president for the state of New Jersey. He died in 1956. (Courtesy of Joan Gorman.)

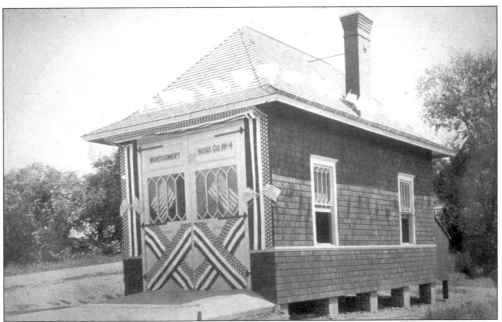

This modest firehouse stood at the corner of Berkeley Avenue and Jerome Place in the early 1900s. In an early example of recycling, this building was moved several blocks east down nearby Montgomery Street to John Street, where it now serves as a residence. A larger firehouse was built on the site and now houses a printing company.

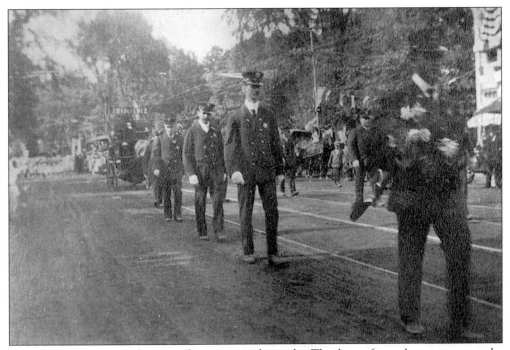

These firemen are marching in the centennial parade. The line of marchers appears to be proceeding south along Broad Street, having already passed the stately elm trees of the Green and the old Peters house, in the right background behind the trees.

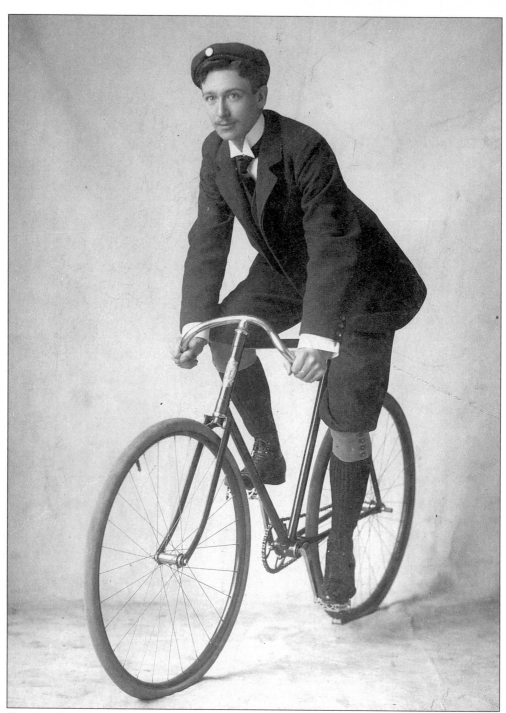

Franklin Stone, of 23 Claredon Place, was the owner of the first "safety bicycle" in town. He later became the owner of the second automobile in Bloomfield. Stone's car was a Torbenson, put together by Mr. Torbenson of Hazelwood Road, who later sold some of his strategic patents to Michigan manufacturers. The first automobile in Bloomfield was owned by Howard M. Thomas of 162 Belleville Avenue.

Willard Miller was the president of the Bloomfield Savings Bank. While in the military, he wrote this note to the wife of George Peterson, who was Bloomfield's mayor from 1902 to 1903: "Dear Mrs. Peterson, I hope this photograph will recall to your mind the little boy you were always so kind to. Sincerely, Willard Santiago, *Dominican Republic Sunday*, September 15, 1918."

In this *c.* 1920 photograph are motorman George Eadie, left, and an unidentified fellow employee. They are at the Caldwell end of the Bloomfield Avenue line of the electric street railway, which became part of the extensive public service transportation system. The change carrier this man wears on his belt identifies his job as being the collector of the extra fares that were required as the car came over the top of what the early settlers of Newark called First Mountain. The men are operating an open car, indicating that it is summertime. Seats ran across the entire width of the car, and it could be entered at any point by simply jumping onto the ample running boards. Many passengers boarded and left these cars before they had come to a complete stop. (Courtesy of Dorothy E. Johnson.)

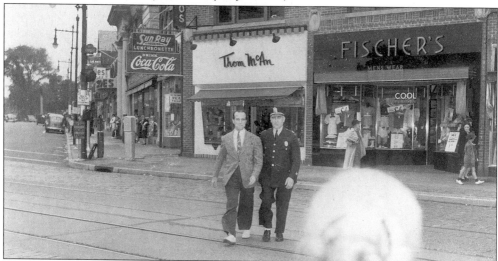

In 1941, the Bloomfield Safety Council initiated a safety program. The program was advertised with posters on a board in the safety island of Bloomfield Center and stressed using crosswalks. Setting a poor example by not using a crosswalk, former Chief Arthur Wilhelm is shown escorting Dal Breitbart, of Fischers Men's Shop. The background of the picture shows the Sun Ray drugstore, Thom McAn shoe store, Fischers Men's Shop, and Parker Photo Studio.

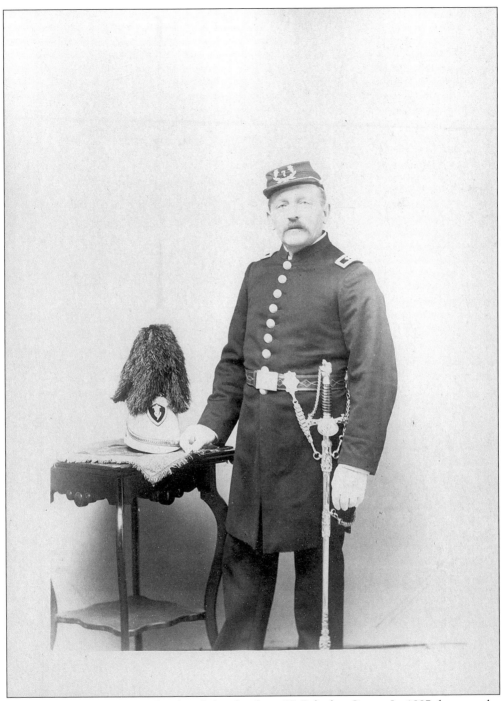

Mayor George W. Peterson lived with his family at 29 Peloubet Street. In 1887, he started a successful business as a painter and decorator. He was a charter member and president of the Essex County Building and Loan Association. Peterson was active in many organizations in town and held positions as an exalted ruler in the Elks and an honorary member of the Essex Hook and Ladder Company No. 1. Here, he poses impressively in his Knights of Pythias uniform.

Albert Loppacker, of Glenwood Avenue, constructed the first automobile built in Bloomfield. It was a two-passenger, 3.5 horsepower car with a speed of 12 miles per hour. The car was built for Torbenson Gear Company in 1900 and was valued at $1,200. Equipped with a J. Deon Boton engine imported from France, it was the wonder of the town for a long time. Loppacker and his helpers built the car inside the shop. When it was ready to take on the road, they discovered that the car was too wide to go through the door and had to be turned on its side to be taken out. Loppacker is shown here with his family, one of whom is Grace Loppacker Plog, whose daughter is married to John Gambling of radio fame.

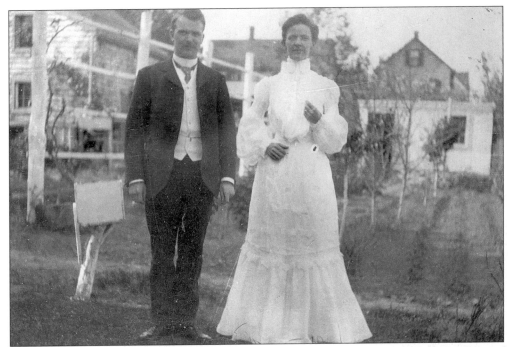

The year was 1903. The bride was Jane Redfearn, daughter of Mr. and Mrs. William Redfearn of 47 Pitt Street. The groom was Harry Wildsmith of England. Jane Redfearn's father had immigrated to the United States from England right after the Civil War. He became a master weaver in the Oakes Woolen Mill. The Redfearn family initially lived on Pitt Street in back of Brookside School before building a house on a plot of land at Watchung and Broughton Avenues.

Posing here are Anna and George Peterson and their son-in-law Fred Dahl. George Peterson and Fred Dahl were partners in a painting and decorating business. Peterson served as mayor of Bloomfield in 1902 and 1903. He died in 1911, and his wife survived him by almost 20 years. They are buried in an unmarked plot in Bloomfield Cemetery.

Mrs. Fred Dahl, daughter of Mayor George Peterson, poses with her children, Lucy, Norman, and Helen.

The Third River runs through Brookside Park, which lies between Broad Street and Morris Place. On a lovely, warm spring or summer day, people of all ages enjoy the popular park by feeding the ducks or using the ball field or the playground equipment. This photograph shows the park in the winter of 1907 and is titled "Snow plowing in Brookside Park." In the background is a Colonial landmark, the Morris Haskell House, which was bulldozed in the mid-1960s.

In 1892, Spragg's Pavilion—located on Glenwood Avenue near the Delaware, Lackawanna, and Western Railroad—became the permanent headquarters of the Bloomfield Cyclers. The group wore a uniform of a blue coat, white sweater or shirt, buckskin cap, and blue trousers. Oakes Mill provided the cloth for the cyclers' outfits.

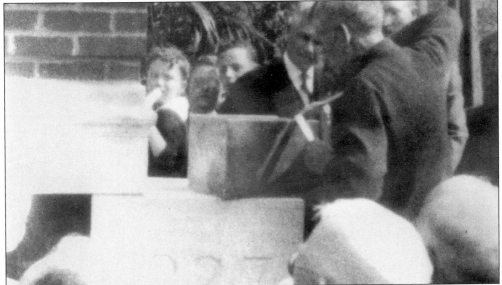

The cornerstone-laying ceremony for the new municipal building took place on May 5, 1928. Patriotic decorations draped the speaker's stand where Gov. A. Harry Moore was given an enthusiastic ovation. Mayor Demarest recognized former mayors and councilmen as they rose to be greeted by the spectators. A copper box, filled with historical information, was placed in the cornerstone. Mayor Demarest spread mortar on top of the cornerstone with a silver trowel. As the stone was put into place, he declared, "May the affairs of this town, administered in this building, always follow the principals of American democracy." The ceremony ended with the spirited crowd singing "America."

John F. Capen came to Bloomfield with his parents in 1870 at the age of five. He was educated in the Bloomfield public schools and at the Newark Academy, graduating with the Class of 1882.

Receiving his architectural training in New York, he later established offices in Newark. He was a fellow of the American Institute of Architects and served for several terms as president of the New Jersey chapter of the institute. Bloomfield buildings designed by Capen include the Children's Library; Knox Hall at Bloomfield College; Franklin, Brookdale, and Carteret schools; an extension to Bloomfield High School; and the now demolished Bloomfield Savings Institution.

Between 1925 and 1930, Cav. J. DiSalvo had his portrait studio next to the Lincoln Theater, later the Broadmoor and then the Center, at 563 Bloomfield Avenue. Around 1930, Aldo Tron posed for this portrait. Aldo's father, Rev. John Tron, was a minister at the Italian Presbyterian Church in Montclair and professor of romance languages at Bloomfield College. Aldo Tron followed in his father's footsteps, teaching both at Bloomfield College and Rutgers Newark.

In the late 1800s, Archie Daily organized the first Watessing baseball team, one that continued for more than 20 years. Bloomfield was a sporting town and Daily was a notable sports figure. By age 16, he had won the state fencing tournament, played guard in football for the New York Athletic Club, and had taken up boxing for a hobby. He played left field for several years and was a hard-hitting batter before taking over as manager of the club. When games were halted by arguments over an umpire's decision, opposing players would leave it up to Arch Daily and promise to abide by his decision, a great testimony to the esteem in which Daily was held. The first diamond for the Watessing team was laid out at the junction of the Erie and Lackawanna Railroads in Watessing. The next stop for the club was on Arlington Avenue and, still later, on Locust Avenue. After Arch Daily's death in 1917, a Watessing team played for a brief time on the top of Watessing Hill, a spot once occupied by a Westinghouse building and part of the Lehn and Fink complex.

Shown is a player from the Watsessing Field Club.

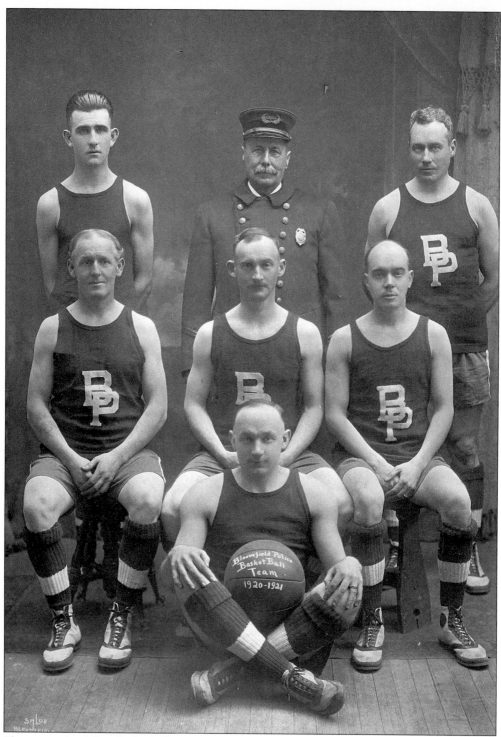

Players on the police basketball team of 1920–1921 include, from left to right, the following: (front row) William Maher; (middle row) Robert Foster, Grover O'Neill, and Ted Seitz; (back row) Charles Hanily, Chief Louis M. Collins, and Timothy Clancy.

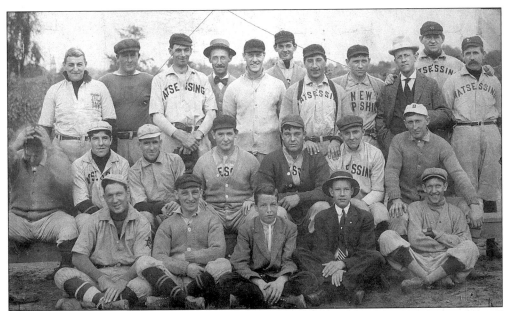

In June 1915, the first game of the town championship was played between the Watsessing and Bloomfield baseball clubs. Cheered on by a good-sized crowd, Watsessing was victorious with a score of 8-7. Next, in a game at the Watsessing Oval, Watsessing played the Nutley AC, who had previously defeated them 5-2. The Watsessing team is pictured here.

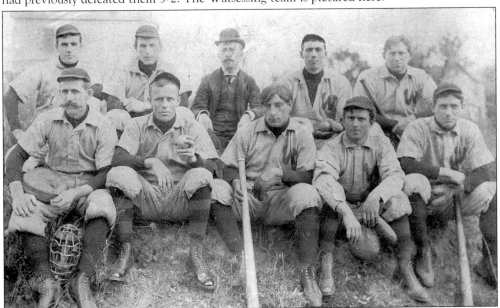

The 1903 Watsessing baseball team was the archrival of the Bloomfield team. Larry Hesterfer, Herbert Fay, and Otto Hambacher were three semipro players, later professionals, who got their start on the Watsessing team. The team's home field was a stadium off MacArthur Avenue, near where the Westinghouse Lamp Company was located. Members of the team pictured here are, left to right, as follows: (front row) Jack Ferguson, Larry Hesterfer, Otto Hambacher, Thorton Shay, and Craig Shay; (back row) Bert Ferguson, Bert Ellor, Coach Robert Sheb, Herbert Fay, and Arch Dailey.

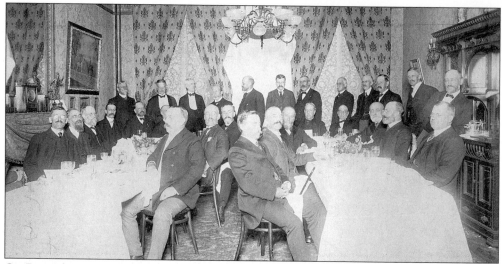

On December 28, 1865, a group of 12 men from town met to form the Young Men's Literary Union for the "improvement in mental culture of its members and the cultivation of a literary taste in our village." In the early part of 1887, when membership numbered 45, the name of the group was changed to the Eucleian Society. The meetings were held in Eucleian Hall, over Horace Pierson's store at the northwest corner of Glenwood Avenue and Washington Street. The society frequently provided lecture courses with noted public speakers.

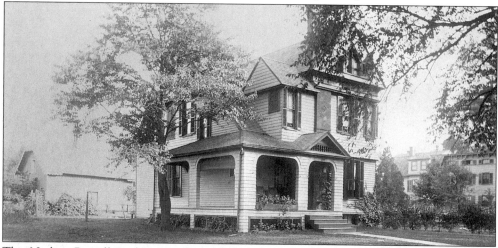

This Nathan Russell Real Estate photograph depicts the residence of Clara Camp, widow of Fred T. Camp, who had died in 1907. Clara Camp moved to West Orange three years later, which was probably when this photograph was taken. Built in 1889, this house at 187 Broad Street was the third constructed for the Camps in Bloomfield. The others were built on Liberty Street in 1885; one still stands, with extensive remodeling. This view, at the corner of Broad Street and Belleville Avenue, shows the previously unphotographed back of the Bradbury house. Modern structures now crowd this corner, and the Camp house no longer looks as though it were out in the country. Camp had his business office at 122 Broadway in New York, which he could easily reach from Bloomfield via the Erie Railroad. In addition to three residences in town, in 1893 Camp also designed the Great Auditorium in Ocean Grove, which seats 6,000 people. Impressive for its size and seating capacity, it is comparable to Radio City Music Hall.

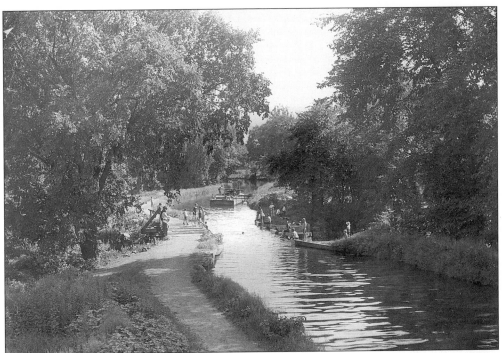

In the 1880s and 1890s, recreation for the boys in summer was swimming. After 1910, the young people donned bathing suits and swam regularly until the canal was abandoned. The incline plane in the north end of town, the places where trees overhung the waters, and the aqueducts near Oakes Pond and Newark Avenue were great places for fun in the lives of many of the town's children. One of the nicest walks in spring was along the canal bank, under the trees, amid the plentiful wildflowers.

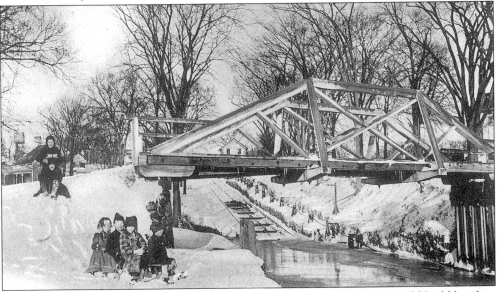

In the winter months, citizens used the canal for a skating rink. The boys would build bonfires on the banks so the skaters could rest and stay warm. Some skated as far down the canal as Paterson or Boonton.

Charles Warren Eaton was a noted artist trained at the Hudson River School. A large portion of his work was done in Bloomfield, although he painted in many locations. As a young man, Eaton painted in watercolor and pastels. Oil, however, was his preferred medium. Eaton received the Silver Medal in the 1904 St. Louis Exposition and the Gold Medal in the 1906 Paris Salon. His paintings are in the National Gallery, the Chicago Art Institute, the Montclair Art Museum, and the Brooklyn Museum. His career spanned 50 years.

For many years, Eaton's home and studio were on Monroe Place. This photograph shows Eaton's house.

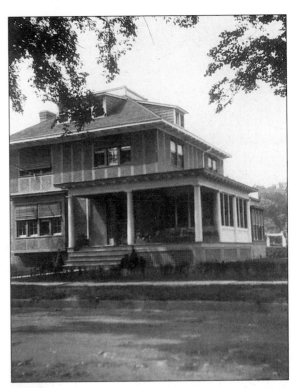

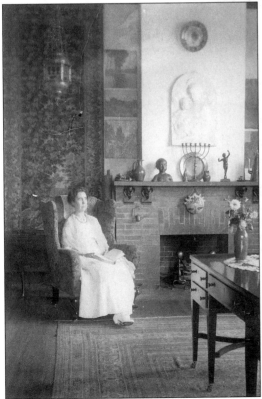

Eaton never married but lived with his older sister, Mrs. Samuel Shaw, and her daughter. They moved to Bloomfield c. 1887 and lived in a house on Monroe Place. Shortly before World War I, Eaton designed and built a house and studio nearly across the street from his first Bloomfield residence. He lived here until his death in September 1937.

This portrait of architect Alexander Jackson Davis (1803–1892) was painted *c.* 1850. Davis is best known for the large mansions that he designed for wealthy patrons in the 19th century. Most are (or were) located in New York City and State. He also designed more modest homes in New Jersey for Andrew Little of Belleville and a Mr. Webster in East Orange. He designed larger homes for Samuel Wilde of Montclair and Llewellyn Haskell of North Arlington (later West Orange). Davis worked for the Stevens family of Hoboken, designing pavilions for their picnic grove, the Elysian Fields, and a clubhouse for the Hoboken Yacht Club, which has since been moved to the Mystic Seaport Museum in Connecticut. Davis died in his Llewellyn Park home in January 1892 and was buried in his family's plot in Bloomfield Cemetery. His grave remained unmarked until 1977, when a memorial stone was placed there by the efforts of the Historical Society of Bloomfield and the Northern New Jersey Society of the Victorian Society in America.

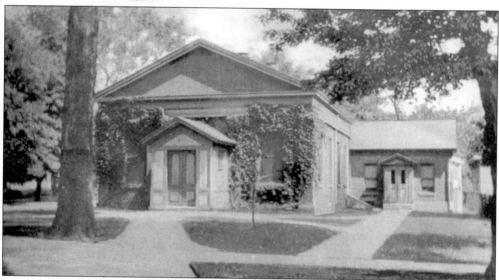

Some of Davis's other designs include the first building for the Christ Episcopal Church in Belleville, the North Carolina and Indiana state capitol buildings, and the entrance lodge and several houses for Llewellyn Park in West Orange. This photograph is of the First Presbyterian Church's parish hall of 1840, which stands at a right angle to the 1796 church. Inasmuch as there were no architects or builders in Bloomfield capable of producing such a superbly designed structure, this Classical Revival building (a small scale replica of the Sub Treasury Building in New York City, which Davis had designed just a few years earlier) is in all probability from the hand of this gifted man, who had many personal connections with Bloomfield.

Mildred Stone was born in her parents' home on Claredon Place on May 21, 1902. Her great-great-grandfather was a founder of the First Baptist Church. She attended Bloomfield schools, starting in kindergarten at the Fairview School, and went on to graduate Phi Beta Kappa from Vassar in 1924. Stone was elected an officer of Mutual Benefit Life Insurance Company in 1937; she was the first woman in the country to achieve such rank in a major life insurance company. She spent 43 years at the company before retiring in 1968. Stone authored six books and was a driving force behind many social service and civic organizations. This 1964 photograph shows Stone receiving recognition from her peers in the insurance company.

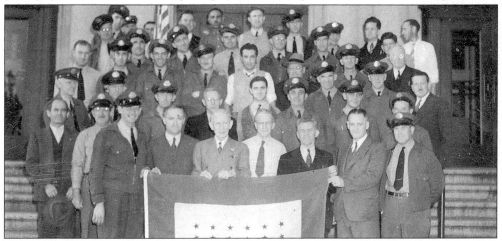

The Bloomfield Post Office was established in 1816, and free home delivery service became available in 1882. For some time before 1895, the post office was located in Horace Dodd's store at 29 Broad Street. The first building erected to serve the post office was at 26–28 Broad Street. After several moves, the post office took up residence in a new building on Municipal Plaza on November 11, 1934. In this 1942 photograph, Bloomfield postal employees proudly display their war service flag.

In 1901, General Electric was established on Noll's Dairy Farm in the Watsessing section. By the time this 1947 photograph of General Electric's payroll department was taken, the air-conditioning division had grown to nearly 2,000 employees. It occupied a large complex of buildings, including Building No. 1, formerly the Sprague Works building, and Building No. 2, which was completed in 1918. Shown, from left to right, at a party honoring Stephanie Doehiver's forthcoming marriage are her coworkers Jack Geiger, Marion Draeger, Jim Lennahan, Roy Zieker, Evelyn Miller, Agnes Bridge, Rose Labrizzi, Beulah Welter, Rose Vandenberg, Martha Karpowitz, Henry Dehm, Rose Fallivene, Ruth Livingston, Jim Finn, Carl Longo, Stephanie Doehiver, and Edith Cool.

Residents of Bloomfield have long enjoyed the pleasures and satisfaction of hobbies such as photography, art, collecting old guns and pistols, antique glassware, theater programs, matchbox covers, and dolls. This photograph shows the members of the Bloomfield Model Club.

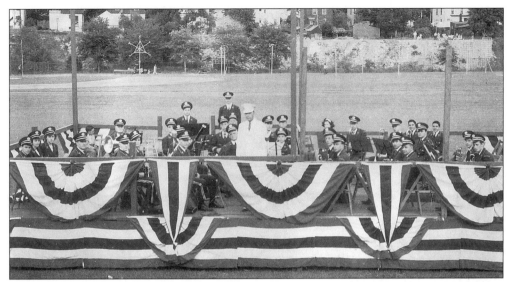

The Civic Band was organized in 1946, shepherded by the Bloomfield recreation commission and superintendent of recreation C.A. "Doc" Emmons. The band was intended as a performing opportunity for local musicians and returning World War II veterans who had played in military bands. In a musical life of more than a half century, over 800 musicians have participated and thrilled audiences with their performances. The band has benefited greatly from the charismatic leadership of its three conductors, Walter Kurkewicz, Ray Hartman, and the present director, Dominick Ferrara.

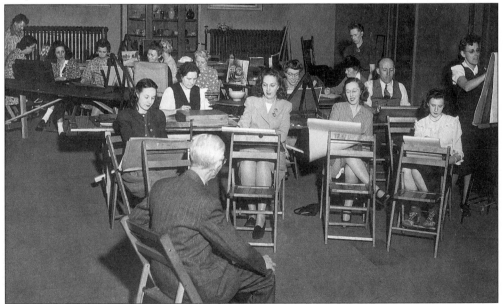

The Bloomfield Art League is an active town club for artists and people interested in art. It was started in 1930 by the Bloomfield Woman's Club. Then the emphasis was on handcrafts, but the women soon started sketching in pencil and before long wanted to add color. A thriving painting class was organized. When sign-ups began, so many men wanted to join that an art group independent of the women's club had to be formed. The Bloomfield Art League was born and continues today.

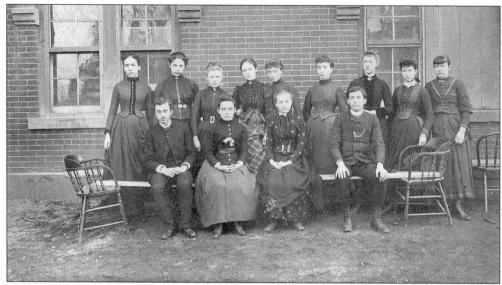

The Class of 1889 poses in front of Center School. The students are, from left to right, as follows: (front row) Theodore Herring, Annie Bowsen, Rosie Zimmerman, and Irving Meeker; (back row) Bertha ?, Inez Davis, Bertha Russel, Laura Ward, Louise White, Eve Suydane, Gussie Madison, Mabel Olmstead, and May Harvey.

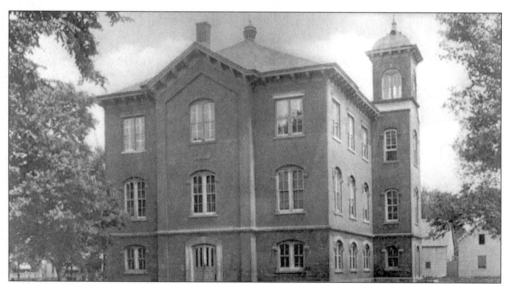

In 1871, the first Bloomfield High School building was erected. At a cost of $30,000, Joseph Kingsland Davis designed an Italianate-style building with towers on the north and south sides. The towers were removed when the building was remodeled in a more classical style. When the new high school was built across the street, this building became Park Grammar School. Later the grammar school moved to what was South Junior High School. The building is now used as the school administration building. This photograph was taken in 1910.

Charles Moreau Davis' Classical School was among the first private schools built in Bloomfield. This building, built *c.* 1850 or 1860, was used by Bloomfield College as a dormitory. It was demolished and replaced by the college's science building *c.* 1969. This is an engraving copied from the border vignettes of important buildings on the 1856 map of Bloomfield.

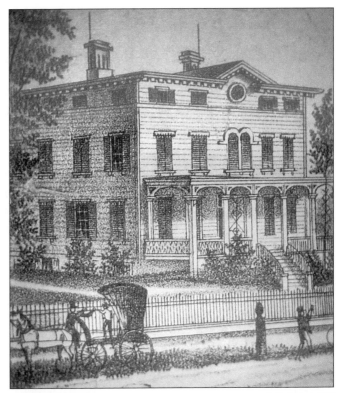

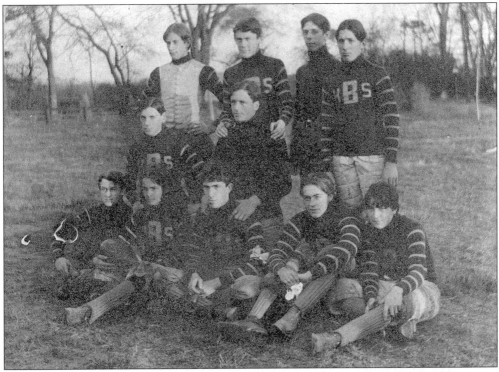

This photograph of the Bloomfield High School team was taken on December 5, 1900.

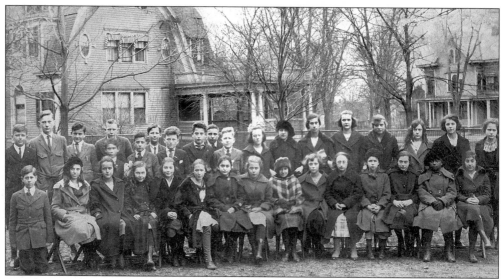

Seen here are the seventh and eighth graders of Park Grammar School in 1921. Those shown, from left to right, are as follows: (front row) Ford Bogart, William Van Wickel, unidentified, Angelyn Burrows, Ethel Jenkins, Virginia Roake, Mary Strazza, Jeanette Nichthausen, Ida Raisbeck, Carolyn Hetzel, Elizabeth Edwards, Janet Ellor, Alma Bowser, and Lucy Sant Ambrogio; (back row) Horace Meeker, Stuart Daland, Vernon Sohner, William Kerwin, Frank Winkler, unidentified, Robert Woodworth, William Perzer, Morris Goldstein, Wallace Zawid, unidentified, Eunice Garvin, Frances Jaeger, Marianne Welker, Beatrice Bennett, Edith Duyal, unidentified, Eleanor Roberts, and unidentified. Lucy Sant Ambrogio served as the curator of the historical society's museum for many years.

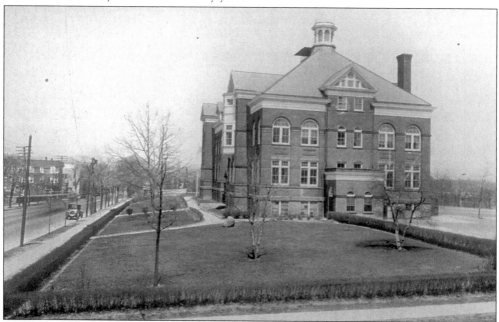

Berkeley School was originally built in 1868 and rebuilt in 1892. The school was given an eight-room addition in 1909, making it the largest in town. Berkeley Home and School Association was founded in 1923 and holds the distinction of being the first in town.

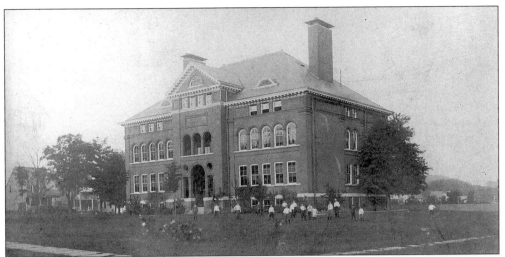

Brookside School was built in 1897 and opened in 1898. Its original seven rooms housed 250 students and 7 teachers. Six rooms were added in 1907, further additions were made in 1923, and more construction continued over the years. The first principal was Lydia Arvilla Martin. She served until 1930, when she retired after 50 years of service to Bloomfield. Brookside School closed its doors in 1980, and the building now houses a condominium complex.

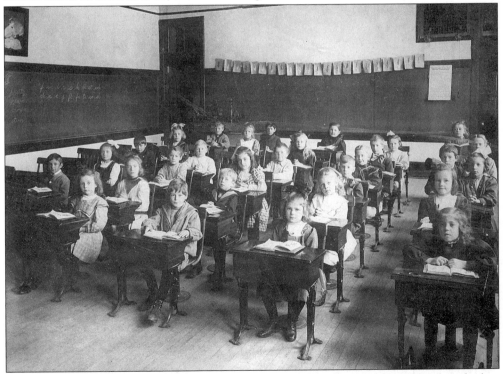

The children seen here are in their Brookside School classroom in 1910. Fred Buck is the boy on the left. Six years later, a diphtheria epidemic struck town, and the board of education, acting on a recommendation of the board of health, voted to delay the opening of schools until October. The Brookside School building was closed for 10 days while the board of health made the school safe.

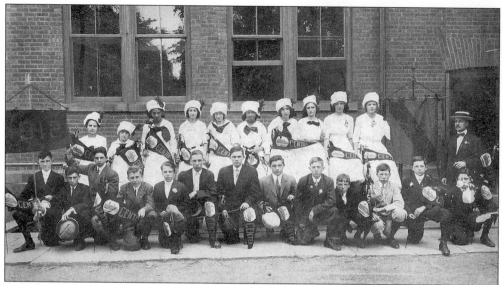

Taking time to have their picture taken before marching in the centennial parade of 1912 is the eighth grade class from Center School. Shown, from left to right, are the following: (front row) George Carl, Howell Logan, Raymond Bloch, Louis Auerbach, Wilber Van Wagoner, Clarence DelHagen, J.C. Johnson, Edward Van Rhien, James Tice, Raymond Sharp, Dean McCroddas, Nicholas Arnold, and Elmer Stager; (back row) Maryland Nichols, Gladys Barry, Bessie Nixon, Marlon Beyer, Anna Johnson, Evelyn Powell, Alice Johnston, Mabel Vreeland, Margaret Ballard, and Helen Morris. Their teacher, Mr. Nobel, is standing on the extreme right. In 1912, Elizabeth Otis was the principal of Center School. The children marched in the centennial parade portraying the sports and holidays of the four seasons.

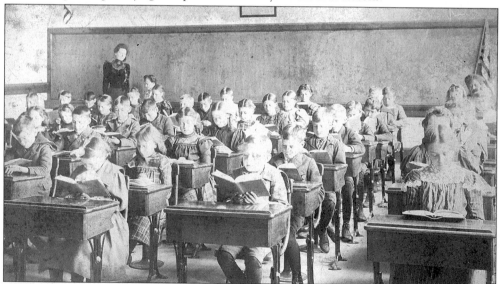

Center School, built in 1890 only three blocks from the Center, stood on residential Liberty Street. It was the second academic building built in Bloomfield. The first was the administration building, originally the town's first high school. Sold to Bloomfield College, it became the college's Austin Hall. After fire destroyed the building, the site was turned into a parking lot for the college.

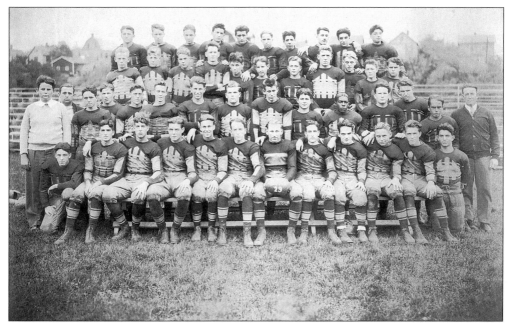

Coach Bill Foley is pictured here with the 1926 football team. Foley came to Bloomfield in 1915 from Goldfield, Nevada, and was hired to coach the high school football, basketball, and baseball teams and to teach commercial subjects. Under his watch, the football team managed a 40-game winning streak spanning from 1934 to the fourth game of 1938. He brought much fame to the town and its top athletes and became a legend among New Jersey coaches. Foley served as the high school's first director of athletics. Bloomfield's athletic field was named in his honor in 1936.

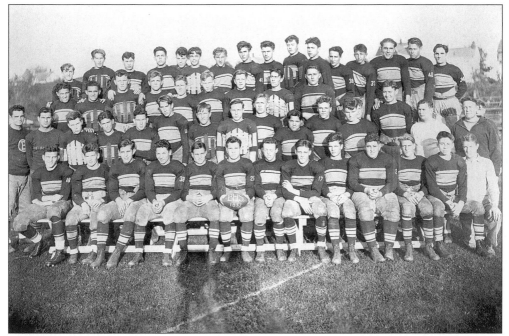

The Bloomfield high school team won the 1933 state football championship.

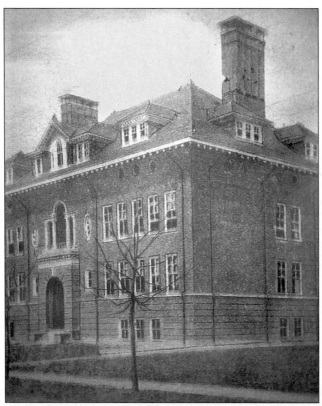

The Watsessing School was built in 1899 at the intersection of Prospect Street and Locust Avenue. When it opened in 1900, the school had an enrollment of 200 from kindergarten to fifth grade. The first principal was Thomas Agnew Jr. Less than one decade later, the school had two six-room additions and was expanded yet again in 1923. The historical society's treasurer, Dorothy Greenfield, remembers playing the harmonica in band practice on the third floor of the school.

These Watsessing schoolchildren were photographed in 1909. In the back row, second from the left, is Gladys Moffat. On the right in the front row is Jessie Cummings Stohl.

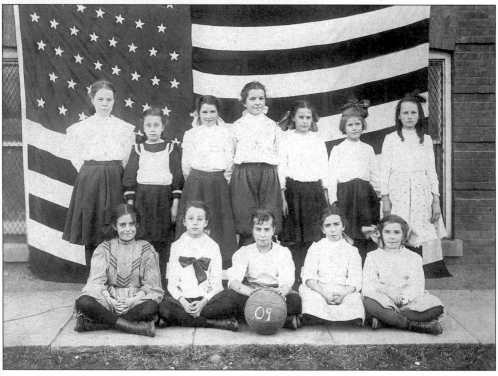

This 1920 photograph is of the Fairview School, named for the district in which it stands. The district included the houses and other buildings centered roughly around the intersection of Berkeley and Newark Avenues. In the late 1800s, with the town's increasing development and population, five new elementary schools were constructed. Fairview School opened in 1899 and, in a little more than two decades, six rooms were added to it.

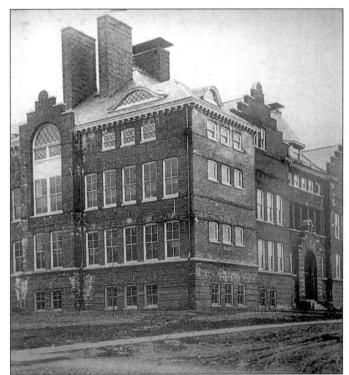

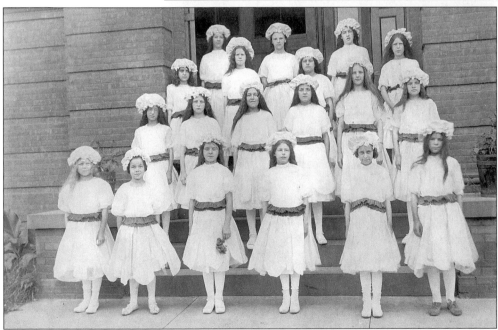

Girls from the Watsessing School, in grades four through eight, marched in the 1912 centennial parade in costumes they made themselves. Other students dressed as Revolutionary War soldiers and War of 1812 sailors. The kindergarten class rode on a float decorated with butterflies, daisies, bumblebees, and grasshoppers. The principal of the Watsessing School at this time was Anna S. Agnew.

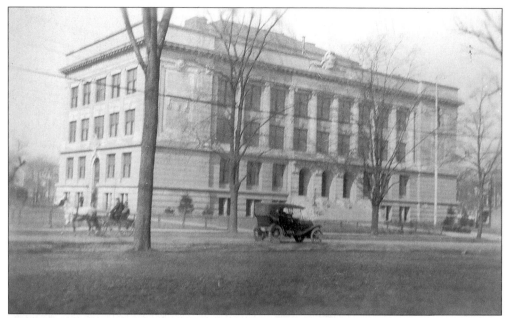

This photograph shows the brand-new high school, designed by architect Charles Granville-Jones shortly after 1912. The original section was built in 1911 and dedicated in 1913; the Belleville Avenue wing was added in 1923; and in 1928 the State Street and Park Avenue wing was constructed. Note the different modes of transportation seen in this photograph.

Pictured is a group of high school teachers. The first principal of the new high school was Ella L. Draper, who remained in that position until 1919. Clara Schauffler is seventh from the left in the front row.

108

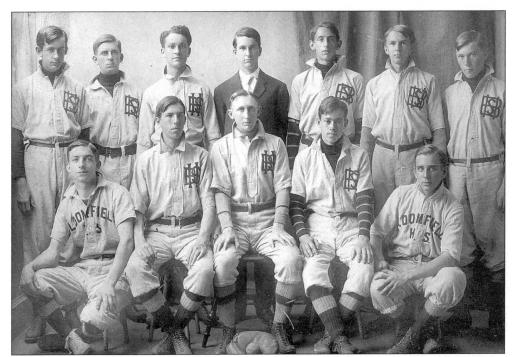

This picture of the 1907 high school basketball team shows, from left to right, the following: (front row) Myrwin Edwards, Bill Biggart, Soup Maxwell, Bob Betts, and ? Mershon; (back row) Harrison Gahs, Mahlon Milliken, Ben Avery, Malcolm Carl, Walter Johnson, Bill Martin, and Fred Storm.

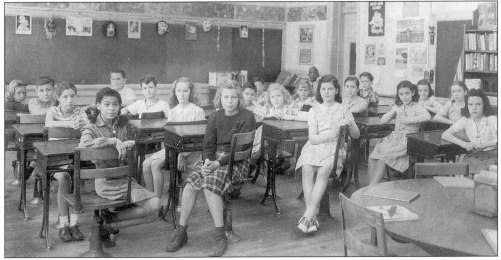

These students from the Fairview School could be Miss Hill's third-grade class of 1942 or Miss Arnold's fourth-grade class of 1943. Joan Swerdlow identified her classmates, from front to back, as follows: (first row at left) Barbara Schyler, Joan Swerdlow, Louis Mondo, and Jean Kurness; (second row from left) Lellene Harrington, Marion Brown, Jerry Lorenz, and David Fenigan; (third row from left) Nancy Roberts, Elizabeth ?, J. Vilante, and William Parsley; (fourth row from left) Patricia Volta, Marjorie McKeon, Carol Ann Pezappi, Doris Koch, Gordon Reeves, Alice Coventry, and Alice Leonard. (Courtesy of Joan Swerdlow Millman.)

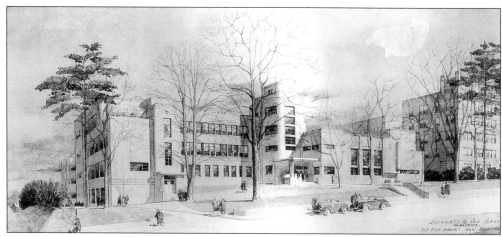

This drawing of the Franklin Street facade of South Junior High School was favored by the board of education over an earlier and more boxlike construction. The rounded corner of the central tower and the arrangement of the windows were considered modern touches when the school was built in 1940. Located on the old Richards estate at the top of Franklin Street, the building cost $1,258,028. A Public Works Administration grant supplied $566,122. The entrance foyer of marble walls and a blue tile floor made a memorable impression. Bloomfield was proud to have one of the finest and most up-to-date junior high schools in the state, if not the country. The school was closed at the end of the 1985–1986 school year.

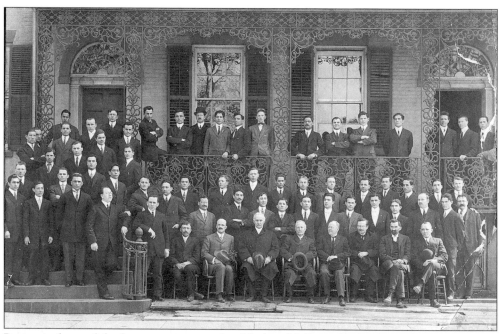

Posing in front of the lacy, cast-iron porch of Seibert Hall are the faculty and students of the German Theological School, c. 1914–1915. Seibert Hall, built in 1807, was named for Dr. George C. Seibert, a member of the faculty for 30 years. Today, Seibert Hall is part of Bloomfield College and is the most historic building on the college campus. (Courtesy of Bloomfield College.)

Four

TOWNSCAPE

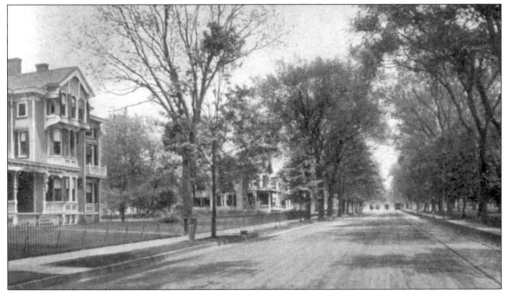

In this view looking north up Broad Street, the home of Judge Amzi Dodd is visible on the left. The car tracks are part of the Orange Crosstown Line, which ran from Belleville Avenue to Eagle Rock. The stately elms on the green were sadly lost to the Dutch elm blight, but hardier species have taken their place.

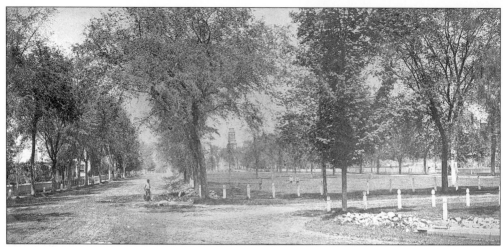

The Green was purchased by the town from Joseph Davis for $200 to be used as a military drill ground. The deed, given by Davis to the trustees, was dated November 27, 1797. When the trustees were unable to raise the required amount, Davis generously granted the property for less than the original agreement. The Green was last used for military purposes in the 1880s when the Bloomfield Battery drilled there before parades and patriotic ceremonies. Through the succeeding years, the Green was the center of town life, with parades, meetings, and concerts. Today it is a public park and provides a setting for Bloomfield College, the library, the civic center, Sacred Heart Church, and the old First Presbyterian Church.

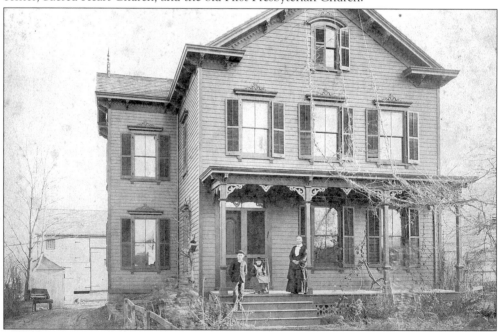

The house at 1195 Broad Street was part of the old Brokaw farm, which stood on the west side of Broad Street, just north of Parkway Drive. Its property extended through the present-day Brookdale Park and, like the Callin farm, may have gone as far as Grove Street in Montclair. This photograph appears to date between 1850 and 1875. The land was used as a working farm until at least 1904. By 1932, Essex County acquired, by eminent domain, the last large pieces of land in Brookdale for the creation of Brookdale Park.

This architect's drawing shows the municipal building, which was designed by W.O. Bartlett and A.B. Marsh.

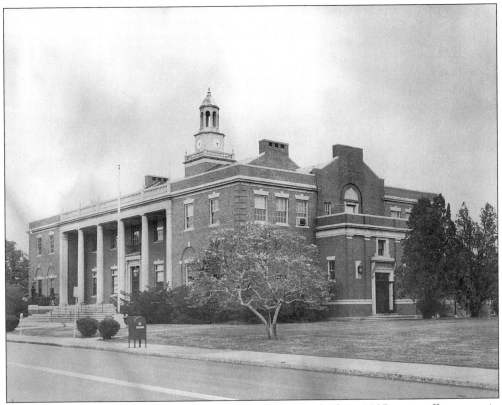

For more than a century before the municipal building was built in 1927, town offices were in rented quarters in various parts of town. With the exception of one addition, the Georgian-style building looks much the same today.

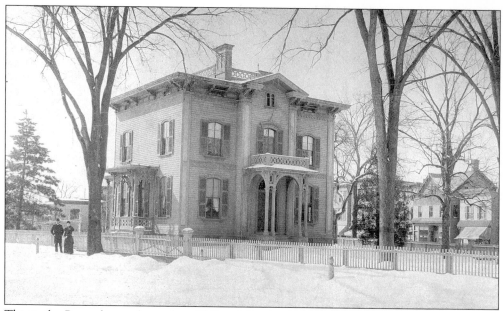

This is the Peters house, located at 47 Broad Street. One of the later owners of the property, Charles H. Nash, poses with his daughter Florence E. Nash.

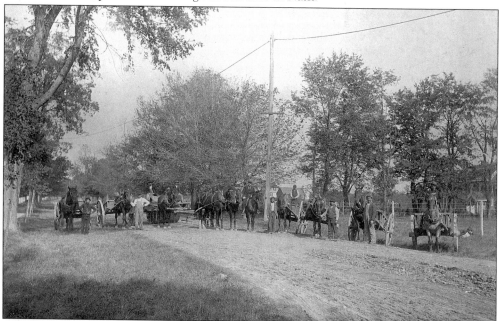

As late as the 1870s, residents complained that the corner of the Green, at Park Place and Liberty Street, was at least a foot below the sidewalk. The roads in town were also very uneven. This is an early view (possibly June 1891) showing the wonderful machinery that helped straighten and smooth the roads. The scraper cost $250 and required a team of four horses and three men. This may be a view of Ashland Avenue with an American Road Machine Company's machine for working dirt roads. It may also be another company's machine called the Western Reversible at work, in the presence of the road committee, on Ashland Avenue and Ella Street or Spruce Street.

This view, looking north, shows the canal bridge at Belleville Avenue.

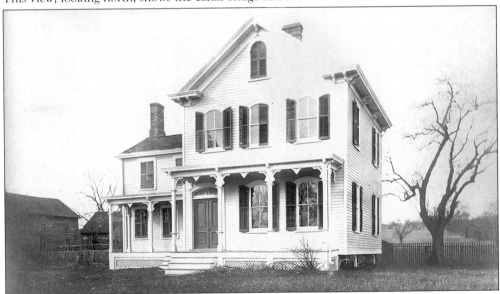

On the 1871 map, the James Callin property extends westward to Grove Street in Montclair. By 1906, Ridgewood Avenue had been continued north through the property, cutting off a large piece of the original farm, which was divided into small building lots. Although the majority of the Callin house dates from the 1870s, the small wing to the left was possibly built as early as the 1830s or 1840s. By 1925, the property was no longer a working farm and had passed into the hands of Francis C. Smith. The house was razed in 1933, and the land is now part of the property of the Glen Ridge Country Club.

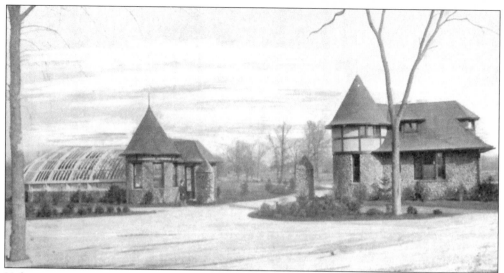

Halcyon Park is bound on three sides by the busy thoroughfares of Berkeley and Watsessing Avenues and Franklin Street. The old Farrand estate was bought *c.* 1898 by Rev. C. Kemper Capron, a minister of the Protestant Episcopal Church who planned on transforming the abandoned farm into a planned community similar to Llewellyn Park. A gatehouse was constructed at the corner of Berkeley and Watsessing Avenues. It still stands today. Opposite the entrance was a similar structure with an attached greenhouse. The park was to be a peaceful and tranquil oasis in the midst of bustling Bloomfield. The financial panic of 1907 put an end to Capron's dream. In 1930, the park was built up and sectioned off. When completed, it contained about 200 homes, far more than originally planned.

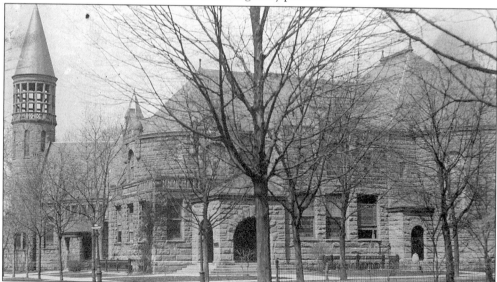

James N. Jarvie built the parish house of Westminster Presbyterian Church in 1902 as a memorial for his parents, who were among the church's original members. Included in the architect's plans were a large hall, parlors, a gym, and a space for a public library. The library later became the Bloomfield Public Library, Jarvie Foundation, and moved to a new building opposite the green. The church building and parish house are now Bloomfield College's Westminster Hall, at the corner of Liberty Street and Austin Place.

In July 1898, the Hope Chapel and property on Hoover Avenue (then Franklin Avenue) were purchased from the Broughton Presbyterian Society for $1,875, including carpeting, seating, and a stove. On October 24, 1899, the St. Valentine's Society took over the Hope Chapel, situated on Hoover Avenue at the corner of East Passaic Avenue. Soon a sacristy was added to the building, an altar and a confessional were erected, and the building was ready to serve as a Catholic church. At a parish meeting on May 14, 1905, a resolution was passed to build a new church, shown here. The first church, Hope Chapel, was moved next to the rectory on East Passaic Avenue and converted into a school. At a parish meeting on January 20, 1924, architectural plans for a new school building were presented. A groundbreaking ceremony for the modern school building was held on April 27, 1924. The cornerstone was laid on July 6, 1924. This foggy, rainy view shows the second church building, which was replaced in 1960.

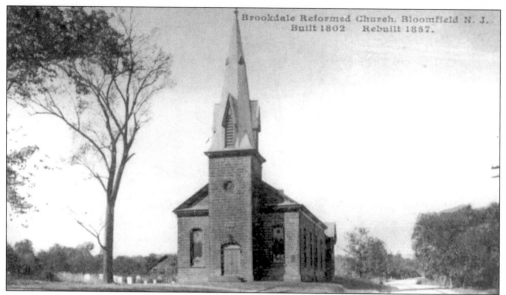

The Brookdale Reformed Church was founded in 1795 by Dutch settlers. Formerly called the Reformed Dutch Church at Stone House Plains, its first brownstone structure was completed in 1802. Following two fires, the church was rebuilt. In the 1930s, the church's farmland was changed into suburban homes and, in 1950, the old Dutch church was redefined as a community church. In 1968, an educational wing was added. The congregation is still strong today.

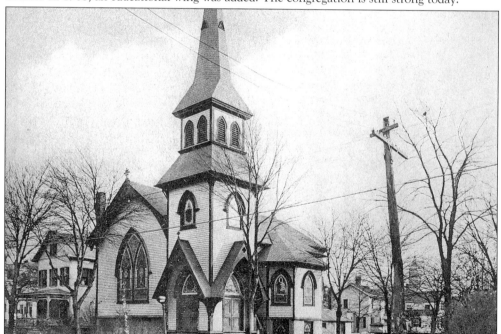

The German Presbyterian Church was organized in 1855. Its founding members were German and the small congregation originally met in the chapel of the First Presbyterian Church. The first pastor was Rev. Christian Wisner and, in 1865, the congregation moved into its first church building. Thirty years later, the German Presbyterian Church on Park Avenue was built. The structure was torn down in the early 1970s.

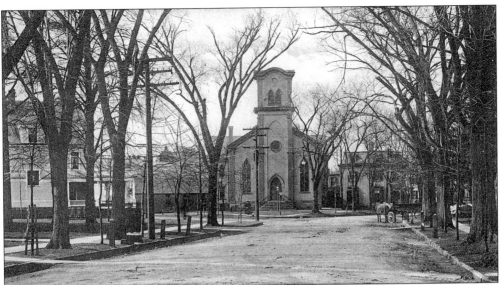

The ministry of the First Baptist Church began when 13 people met to organize in November 1851. The Franklin schoolhouse on Zion Hill, Lower Village, was their first place of worship. In 1852, land was purchased at Franklin and Washington Streets and a completed church opened for worship in 1853. Fire destroyed that building and, in 1910, the present church was erected.

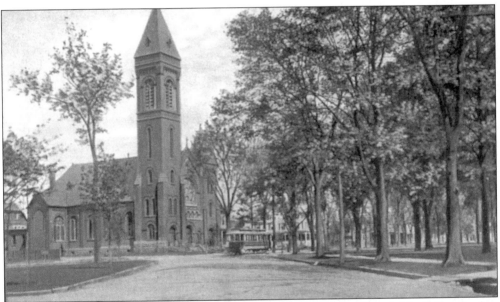

Sacred Heart Church was established on July 6, 1878, when Father Joseph Nardiello, the first pastor and founder, celebrated Sunday Mass in Friendship Hall, in the old Bloomfield Hotel at Broad Street and Bloomfield Avenue. Until this time, Catholics living in the central part of town had to attend church at the Immaculate Conception Church in Montclair or at St. Peter's Church in Belleville, which were a part of Bloomfield at the time. By 1878, the congregation built a church on Bloomfield Avenue. That building was used for worship until the present stone-and-brick structure at Broad and Liberty Streets was dedicated on October 16, 1892. The original church was used as a lyceum until it was razed in 1922.

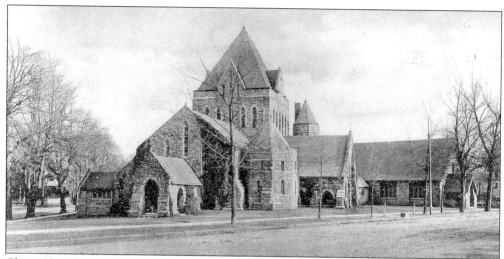

Christ Church was organized on October 4, 1858. The church was built on the corner of Liberty Street and Austin Place. On January 11, 1893, Christ Church and the parish house were destroyed by fire. Glen Ridge churchgoers were persuaded to give up plans to build their own church and united with Christ Church in a new building, which was erected on the present site of Bloomfield and Park Avenues.

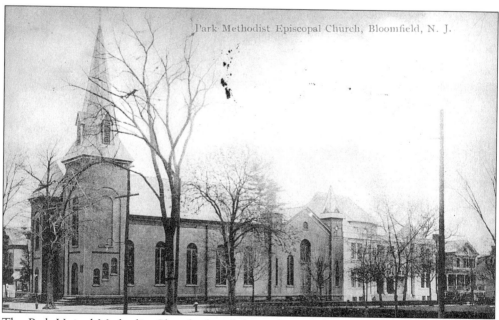

The Park United Methodist Church, founded in 1821, is the third oldest religious group in Bloomfield. The Gothic structure, which now faces the Green at the corner of Broad and Park Streets, is the third building that has housed the congregation. It was built in 1928, and the adjoining parish house was built in 1965 of granite from the same quarry. The first Methodist church was built in 1821, when the only other churches in town were the First Presbyterian Church on the Green and the Dutch Reform Church in Brookdale. The church has since been nearly doubled in size with an extension westward toward Bloomfield Avenue.

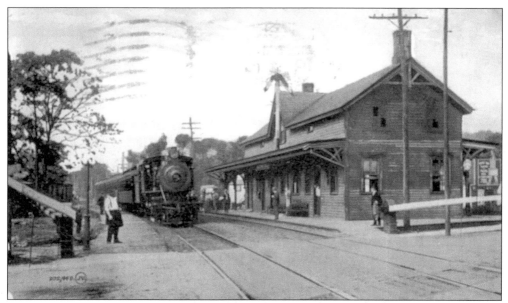

This pre-1912 image shows the Glenwood Avenue station of the Delaware, Lackawanna, and Western Railroad. It appears here before electrification and elevation modernized the old Newark and Bloomfield Railroad, which was begun in the 1850s as a replacement for the Newark-Bloomfield stagecoach. "The Stage," as it was called, had been the only way to travel to the nearest big city. Despite grand names, such as the Newark and Pompton Turnpike, the roads were little more than dusty, muddy wagon tracks.

The electrification of the Delaware, Lackawanna, and Western Railroad forced many changes in the landscape along its route. Tracks were relocated and all of the original wood-framed stations were replaced with modern concrete and brick structures. The old street-level tracks at Glenwood Avenue, which remained in use during these changes, were finally torn up and replaced by a new street. This scene of the Lackawanna depot after 1912 retains much the same appearance today.

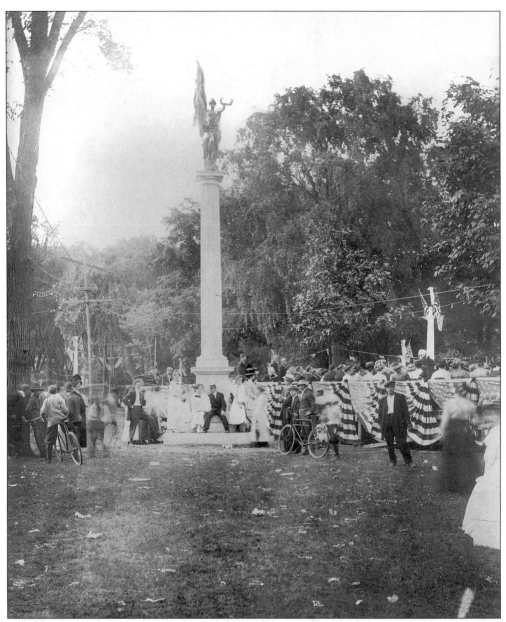

Bloomfield's 100th anniversary on March 23, 1912, was observed both at that time and with a week of celebration in June. The town committee designated this as "a time to arouse Civic Pride and rekindle Patriotic sentiment." The town's actual birthday was marked with a ceremony at the First Presbyterian Church. John Franklin Fort, former governor of New Jersey, was the speaker. Further events were scheduled to take place in June for fear of inclement weather in March. One of the highlights was the unveiling of the Soldiers and Sailors Monument, which today stands at the end of the Green. David G. Garabrant served as chairman of a committee, along with William P. Sutphen, Charles A. Hungerford and Theodore H. Ward, to select an appropriate memorial to the soldiers and sailors who had served in the nation's wars. Sally James Farham, a student of Frederick Remington, designed the memorial. The cost was defrayed by subscription among schoolchildren, who raised $5,000.

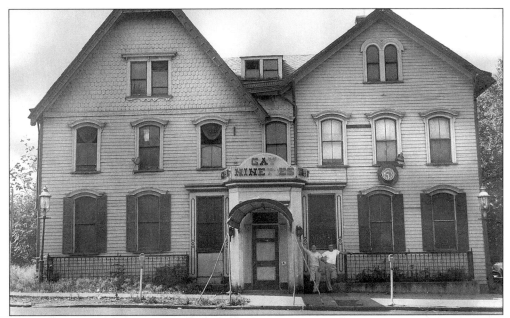

As is suggested by the unusual facade, the Metz Hotel was a combination of two 19th-century buildings, from slightly different dates, which were merged into one large structure. Adam Metz was a baker whose first shop was on Canal Street, now Maple Street. He purchased property on Bloomfield Avenue, planning to expand his bakery at this location. Two Newark friends persuaded him to open a tavern, instead of a bakery, because they both were commercial bakers who already supplied Bloomfield with baked goods. When Metz passed away in 1890, his four sons continued the business. This 1953 photograph shows Jim Foster (at the door) and Chick Foster outside the Metz Hotel. The building was destroyed in September 1954.

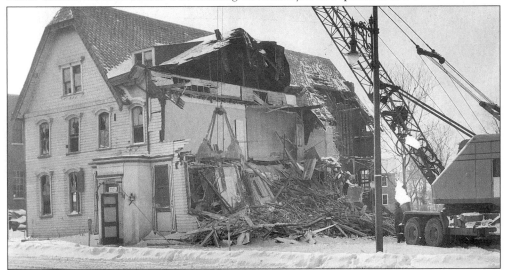

In January 1954, the hotel building was razed to make room for a Garden State Parkway bridge. During demolition, the left front wall was removed, disclosing the large hall that comprised the second and attic floors. The roof of the hall was supported by massive trusses decorated with wrought-iron tracery and Victorian gingerbread. The owners had remodeled the old hotel into a nightclub called the Gay Nineties.

This photograph of Watsessing Center was taken in 1917. The Dodd homestead, in the background, stood at the corner of Dodd and Myrtle Streets. The gentleman standing at the gate is "Sal," a barber.

The first-floor courtroom in the municipal building was decorated with this mural by artist Natalo Mazzeo. The courtroom has moved to a new addition in the building, and the mural now graces the tax office.

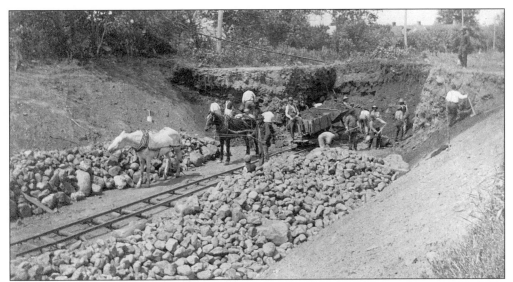

This photograph was taken during the construction of Watchung Avenue. In 1945, the town planning board recommended that the road be extended between Broughton Avenue and East Passaic Avenue to connect with east Passaic. The town poorhouse was an old frame building located on an irregular plot of ground on Watchung Avenue. It was poorly located and had been criticized by the Town Improvement Association and social welfare workers. It was determined that the best way to care for the town's poor was to use the facilities of the Orange City Almshouse in Livingston at a cost of $5 per week. The poorhouse and farm were briefly rented and later sold.

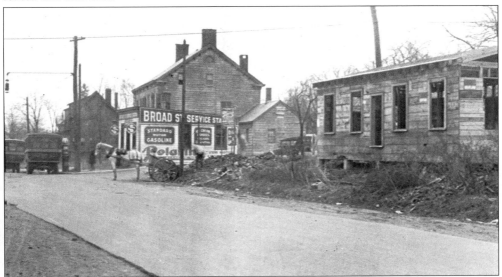

This c. 1920 photograph, looking south, shows the intersection at Broad Street and Bay Avenue. At one time, this marked the northern end of Bloomfield's paved roads. The trolley also ended its route here, leaving many northbound passengers to hitch a ride home. Today, the intersection is surrounded by two gas stations, a garden center, and Brookside Park. Even in 1920, there was a gas station located on the corner, and motorists pulled up to the curb to get petrol. The picture was taken in front of the home of John Ganser, a local tavern proprietor who also opened one of the first "dining cars" in Bloomfield's North Center.

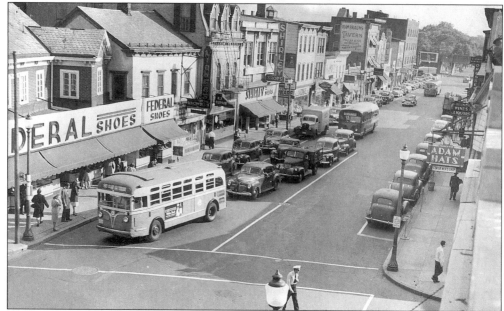

The Federal shoe store, left, opened in 1949. Just beyond are New Jersey Shoe Repair and the Shirley Shop, which specialized in women's clothing. (Both of these buildings, among the oldest in the Center, were destroyed by fire in the mid-1990s.) After the driveway, United Hardware occupied the ground floor of a building that has since been torn down and replaced by a modern structure. Farther down the block is Braun's Tavern, on the site of Reuben Dodd's second livery stable, which he built after his Broad Street establishment was ruined in the 1883 fire. Appropriately, the firemen in Phoenix Hose Company No. 1, across the street, kept their horses in Dodd's stable. Far in the distance is the bridge of the Delaware, Lackawanna, and Western Railroad. At the corner is the No. 90 crosstown bus, which ran about every two hours.

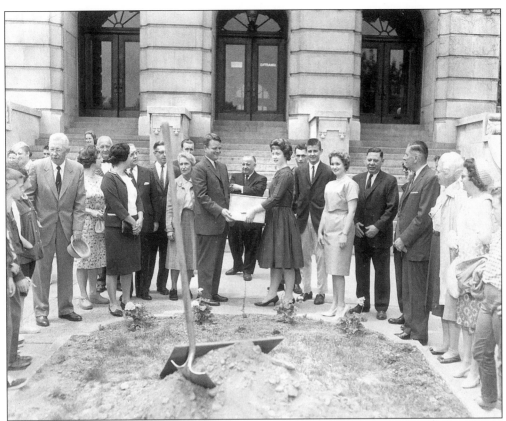

High school students prepared a time capsule for Bloomfield's sesquicentennial celebration. The stainless steel capsule contained pictures of students, activities, independent articles, copies of the school newspaper, signatures from every high school student, and other memorabilia of life in 1962. Many people took part in the ceremonies, including Mary Bringewatt (student council president), Edward Karytko (vice president), Alan Costa (president-elect), Mildred Stone, Harold Brotherhood, and Mayor Steinmann. This photograph, taken in front of the high school, shows the temporary burial place of the capsule. When the cornerstone of the new high school gym was set in place, the capsule was transferred into it. The capsule is scheduled to be opened on Memorial Day 2012.

Opposite, bottom: The original Bloomfield cemetery occupied five acres along Belleville Avenue. Around 1796, the land was given to the old First Presbyterian Church by Issac Ball, a church member and early settler of Bloomfield. North of the property, some land was then still owned by the Ball family. It contained valuable clay pits, which furnished the material for the bricks used in many local structures, and the town's first skating pond. Around 1850, the cemetery was enlarged when the rest of the Ball property was purchased for $1,500. Many members of the town's original families are buried here, including Mr. and Mrs. Ball. Ten Revolutionary War soldiers have their graves here. William Bradbury (19th-century composer of religious music, including "Jesus Loves Me"), Franklin Fort (former governor of New Jersey), Charles Warren Eaton, and Alexander Jackson Davis are interred in the cemetery as well. The beautiful 1905 cemetery gatehouse, which contains an office and meeting room for the board of trustees, has recently undergone a total renovation, including the installation of a new slate roof. Redecorating and refurnishing the interior are planned.

A full century after the formation of the original Newark colony, the section that became the town of Bloomfield finally constituted enough of a community to build its own church. Preparations were made for breaking ground in the autumn of 1796. In admiration of the Revolutionary War general Joseph Bloomfield (shown here), the name Bloomfield was selected for the parish. A letter was written to the general, informing him of the people's choice. The general accepted the honor and visited "his" town on Thursday, July 6, 1797. Bloomfield, accompanied by his wife, entered the town by way of Orange with a large procession of clergy members, schoolchildren, citizens, and workers hired for the church construction. He contributed $140 toward the building of the new edifice and several volumes for the church library. Bloomfield's wife donated a handsomely bound Bible and psalm book. In addition to his distinguished accomplishments in the army, Bloomfield served as governor of New Jersey from 1803 to 1812. When, on March 23, 1812, the township of Bloomfield was formed, its citizens followed the lead of the first parish and chose the name of this revered patriot for their new town.